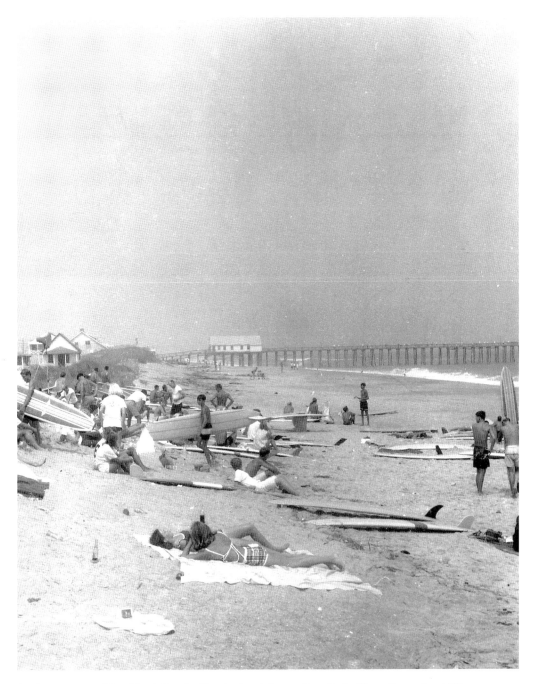

Surfing contest at Kitty Hawk Beach. *Photo by Aycock Brown, Outer Banks History Center, circa 1963.*

VINTAGE
OUTER BANKS

SHIFTING SANDS & BYGONE BEACHES

SARAH DOWNING

THE
History
PRESS

Published by The History Press
Charleston, SC 29403
www.historypress.net

First published 2008
Second printing 2010
Third printing 2010
Fifth printing 2013

Manufactured in the United States

ISBN 978.1.59629.508.7

Library of Congress Cataloging-in-Publication Data

Downing, Sarah.
Vintage Outer Banks : shifting sands and bygone beaches / Sarah Downing.
p. cm.
ISBN 978-1-59629-508-7
1. Outer Banks (N.C.)--History--Pictorial works. 2. Historic
buildings--North Carolina--Outer Banks--Pictorial works. 3. Historic
buildings--North Carolina--Outer Banks--Pictorial works. 4. Summer
resorts--North Carolina--Outer Banks--History--Pictorial works. 5.
Hotels--North Carolina--Outer Banks--History--Pictorial works. 6.
Restaurants--North Carolina--Outer Banks--History--Pictorial works. 7.
Business enterprises--North Carolina--Outer Banks--History--Pictorial works.
8. Beaches--North Carolina--Outer Banks--History--Pictorial works. I.
Title.
F262.O96D69 2008
975.6'1--dc22
2008031398

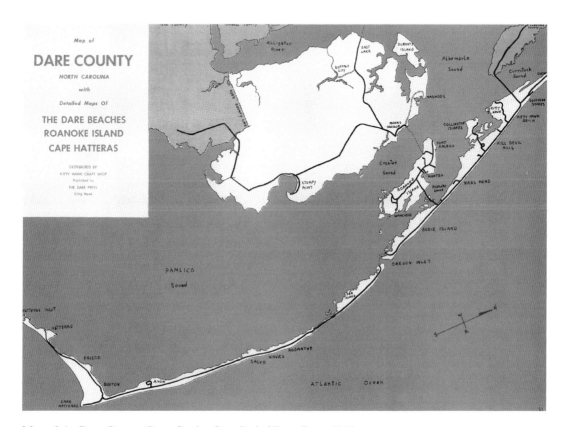

Map of the Dare County Outer Banks. *Outer Banks History Center, 1950.*

Contents

Preface

Much research for this book came from sources at the Outer Banks History Center in Manteo, North Carolina. Especially useful were vintage tourism publications, including *Surfside News*; *North Carolina Coastal Fishing and Vacation Guide*; *Dining on the Outer Banks: Restaurants, Dining Rooms, Motels*; and *Dare Coast—Dare Mainland and the Outer Banks*. Several periodicals were also consulted, such as the *Coastland Times*, the *Virginian Pilot*, the *Independent*, the *News and Observer*, *Our State Magazine*, *Outer Banks Magazine* and *Outer Banks Edge*. The History Center also has hours of recorded oral histories. A few tedious facts had to be confirmed at the Register of Deeds Office.

Over the years, scores of interviews were conducted (both formally and informally) with anyone who might have a tidbit or substantial information to share about the area's past.

First and foremost, I would like to thank author and historian David Stick, who donated his personal papers and library to create the Outer Banks History Center, a regional archives and research library administered by the North Carolina Office of Archives and History. He has inspired me, along with countless historians.

The staff of the Outer Banks History Center–KaeLi Spiers, Christine Dumoulin, Tama Creef and Courtney Clarke–were always cheerful and obliging while I worked on this book. Bill Garrett and Chandrea Burch, at the North Carolina State Historic Preservation Office, helped locate a recent photo of Newman's. Penne Sandbeck was encouraging throughout the entire project, and I appreciate her help editing the manuscript. George Barnes, at Jockey's Ridge State Park, shared stories and allowed me to search the park's photographic collection. Kathy Huddleston, at the Manteo Library, and Mona Robinson, at the Dare County Register of Deeds Office, were helpful guiding my searches. My husband, Steve Downing, was a constant source of support. Special thanks to Kent Priestley, who started the ball rolling.

I would also like to acknowledge the photographers whose works made this book come to life–Drew C. Wilson, Roger P. Meekins, Penne Sandbeck, Ray Matthews and the late Aycock Brown.

Thanks especially to the many, many people I talked to, telephoned, pestered or visited. Some shared memories; others put me in touch with key people with whom I needed to speak in order to make the book complete.

Introduction

From Kitty Hawk to Whalebone Junction and west to Roanoke Island's villages of Manteo and Wanchese, North Carolina's North Dare Outer Banks are rich in history, beginning with Native Americans, who fished its waters teeming with shellfish and aquatic life and hunted in its maritime woods. In the late sixteenth century, England's first attempts to colonize the New World took place at Roanoke Island. The tragic end of that venture has since been immortalized in the annual outdoor drama, *The Lost Colony*. Life took a quieter tone over the following two hundred years, bringing tenant farmers and fishermen to these coastal shores, until the War of 1812, when British ships cruised the shoreline and soldiers came ashore to plunder the countryside.

During the Civil War, a fleet of ships carrying soldiers led by General Ambrose Burnside sailed down the Chesapeake Bay and out into the Atlantic Ocean, through Hatteras Inlet and up to Roanoke Island, where the first major modern amphibious landing took place. After the Union took control of Roanoke Island in 1862, a colony of newly freed slaves set up camp under the direction of the federal government and Northern missionaries.

Orville and Wilbur Wright made history at Kitty Hawk when they sailed their heavier-than-air machine for seventeen seconds, introducing aviation early in the twentieth century. World War II brought German U-boats dangerously close to the coast, where they torpedoed American and foreign tankers.

However, there is a lesser-known history of this place that has grown into a booming tourist resort known for its beautiful beaches, historic attractions, fishing and recreational opportunities. This history begins with the building of roads and bridges and the idea of early visionaries to attract outsiders to Dare County to build a tourism economy. The first steps took place in the late 1920s and the 1930s, with a secondary push after World War II. It is the story of early hotels and restaurants run by individuals and families, who provided food and lodging to the nascent industry of tourism, and those who worked to promote it.

It is also about early venues for entertainment on the upper Dare Beaches, when dance halls and bingo parlors were the entertainment of the day. Many of these enterprises are treasured memories of early vacationers, and it is hoped that this book will keep them alive in memory.

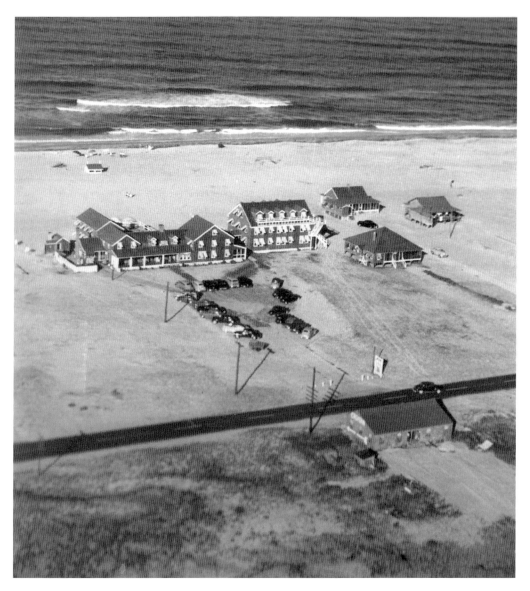

The Croatan Inn was one of the first oceanfront hotels on the Outer Banks. *Photo by Aycock Brown, Outer Banks History Center, 1952.*

The Croatan Inn

The Croatan Inn was built in the early 1930s, shortly after the Virginia Dare Trail, the paved thoroughfare later known as the Beach Road, was completed. Skipper and Bernie Griggs, the inn's owners, were true pioneers of the Outer Banks tourism industry. With the completion of the road, land began to sell. The Griggses chose a landmark spot to build their new establishment, a section of the beach in what would later become the town of Kill Devil Hills, directly in front of the shipwrecked *Irma*, which had gone aground in 1925. Mrs. Griggs owned the Hampton Lodge at Waterlily in Currituck County, which catered to sportsmen. This gave the couple an automatic pool of clients to lure to their new facility on the beach.

The Croatan Inn, near Milepost 7.5, was constructed in stages over the years. The original portion, with its cedar shake exterior and shuttered windows, had a welcoming lounge area with a brick fireplace and juniper paneled walls. The first guestrooms were small and lacked private baths.

Lindsay Warren, a highly esteemed congressman from the area, vacationed at the Croatan Inn, as did members of the press from Washington, D.C., such as broadcaster Fulton Lewis Jr. and columnist Ray Tucker. Philanthropist Joseph P. Knapp and his wife, Margaret, also frequented the Croatan. Many families vacationed at the inn year after year, attracted by its casual beachy atmosphere and delicious food. Tom and Susie Briggs later took over ownership, followed by Robert and Laura Tupper.

Guests enjoyed meals in the elegantly simple oceanfront dining room, with its beamed ceilings and windows on two sides that were dressed with red and white striped awnings. Drinking took place upstairs in the Wheelhouse Bar.

Papagayo Restaurant operated in the Croatan Inn from 1981 to 1995 and was immensely popular with both locals and visitors. On average, Papagayo served over four hundred Mexican dinners a night. All sauces, salsa, side dishes and salad dressings were made in house from scratch. Especially popular dishes were the crab enchiladas, cheese and pepper chicken, shrimp chimichangas, Mexican pizza with sopapillas and Mexican chocolate cake for dessert.

In 1996, John Kirchmier bought the building, and from 1996 to 2006, Quagmire's Restaurant called the Croatan Inn home. During the days of Papagayo and Quagmire's, the upstairs bar and deck continued to be a favorite gathering spot, where many locals

would get together on Sunday evenings to enjoy live music while sipping margaritas, frozen daiquiris or a beer.

The Outer Banks lost one of its first twentieth-century landmarks when the Croatan Inn was torn down in March 2006.

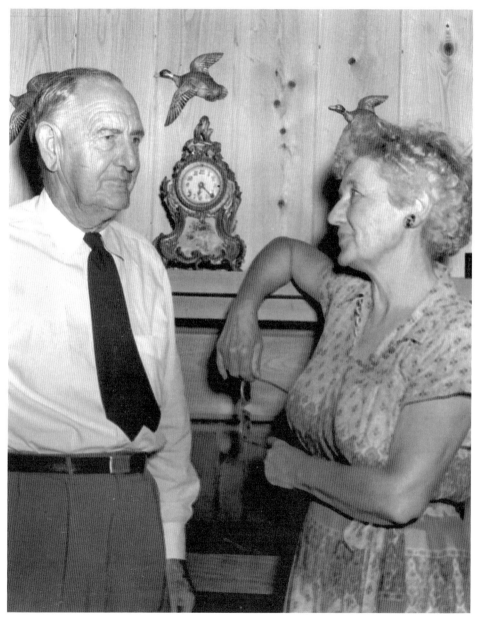

Skipper and Bernie Griggs, the Croatan's first owners, pose in the lobby. *Photo by Roger P. Meekins, Outer Banks History Center, 1950.*

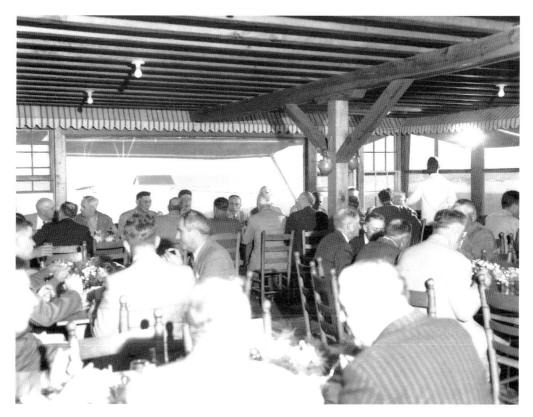

A banquet or get-together in honor of Congressman Lindsay Warren, who is seated at center in front of the picture window, to the right of Congressman Herbert C. Bonner. *Photo by Aycock Brown, Outer Banks History Center, circa 1953.*

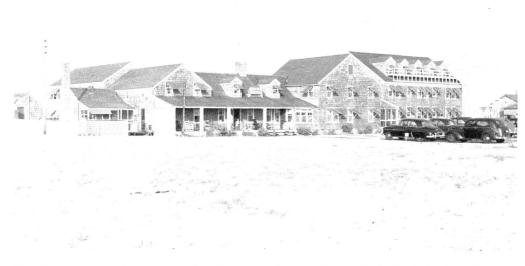

The Croatan's popularity drew returning visitors year after year. Pictured is the inn during its heyday. *Photo by Aycock Brown, Outer Banks History Center, 1952.*

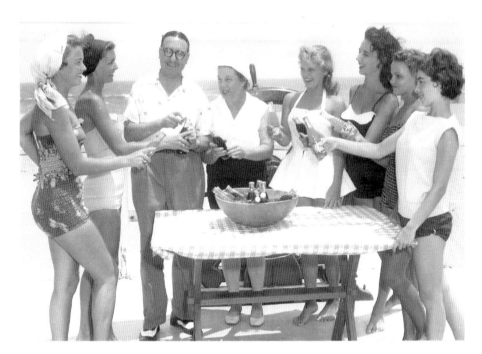

Tom and Susie Briggs host a soda pop party on the back deck of the Croatan. *Photo by Aycock Brown, Outer Banks History Center, circa 1958.*

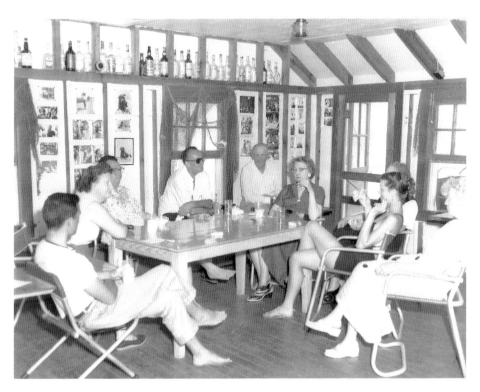

Guests relax in the Wheelhouse Bar. The screen door led to a deck that was also a popular spot. *Photo by Aycock Brown, Outer Banks History Center, circa 1954.*

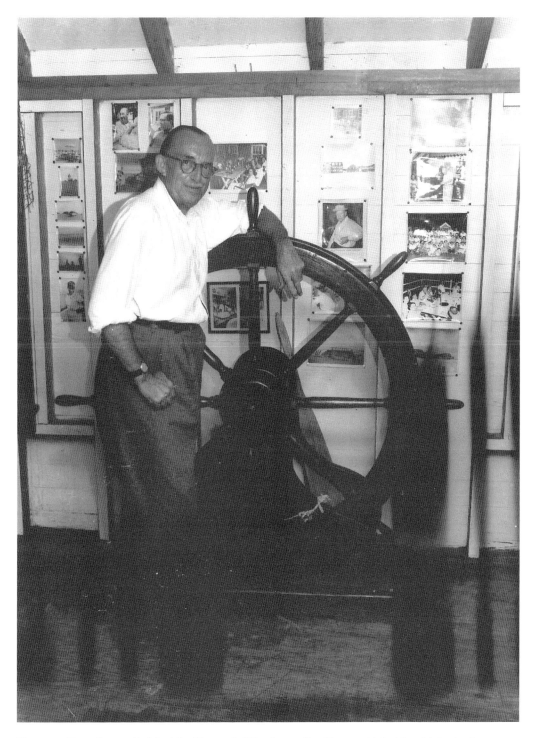

Illustrator Dean Cornwell visited the Croatan's Wheelhouse Bar. It was said that the ship's wheel came from the shipwrecked *Irma*, which went aground in 1925 near the future site of the Croatan. *Photo by Aycock Brown, Outer Banks History Center, circa 1954.*

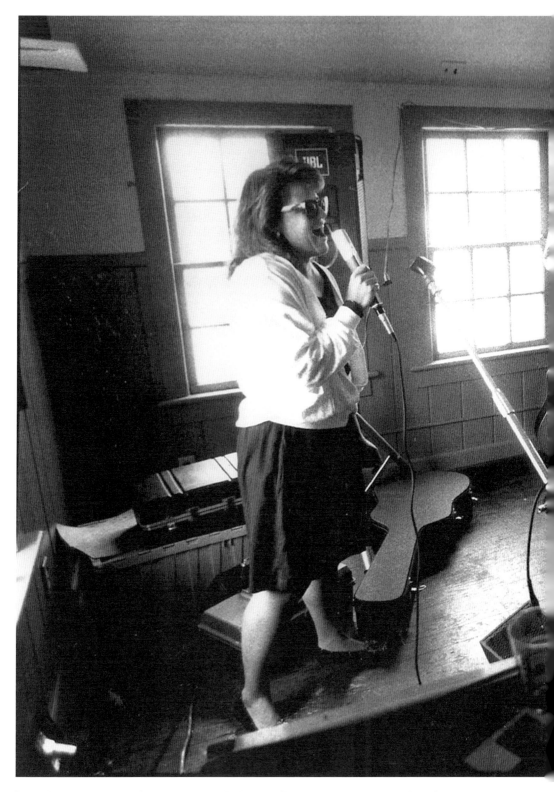

Laura Sholes, vacationing from Richmond, Virginia, performs an impromptu rendition of Gershwin's "Summertime" in the upstairs bar. *Photo by Drew C. Wilson, Outer Banks History Center, 1990.*

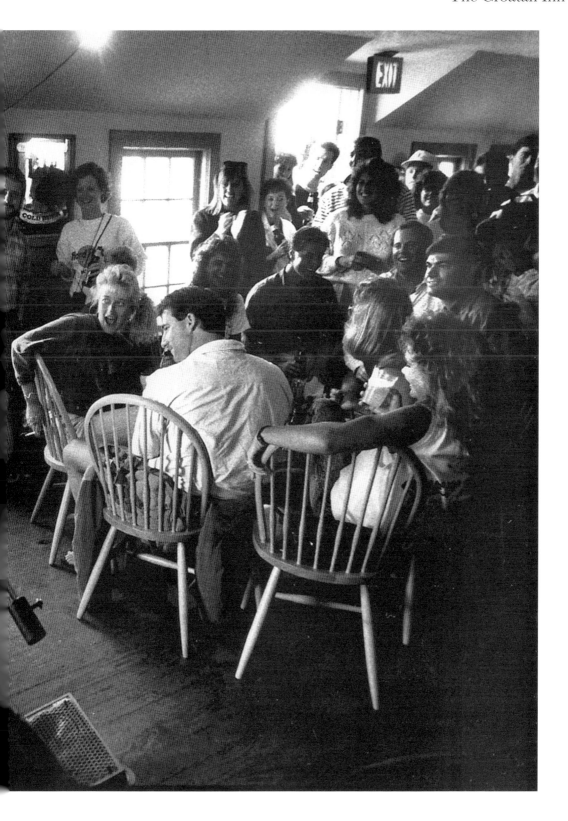

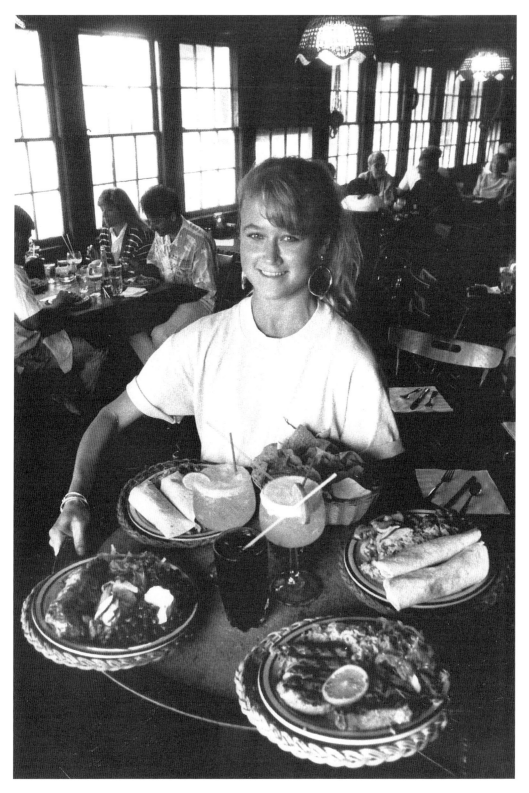

Papagayo waitress Lisa Long shows off a tray of Mexican specialties. *Photo by Drew C. Wilson, Outer Banks History Center, 1990.*

The Nags Header Hotel and Nags Head Beach Club

The Nags Head Beach Club was built in 1934, chiefly financed by Braxton Dawson of Elizabeth City, North Carolina. It featured bands, such as the Carolina Corsairs and the Duke Ambassadors, and dancing on its forty- by seventy-foot wooden dance floor. The club was also a popular late-night spot, where the cast and crew of *The Lost Colony* gathered after performances at Waterside Theater and, once again, went onstage to appear in improvisational song, dance and comedy routines. On Sunday afternoons, the Nags Head Beach Club hosted tea dances. The exterior of the club featured a wraparound porch that was well equipped with wooden rocking chairs.

The following year, the Nags Header Hotel was built just north of the Nags Head Beach Club at a cost of $20,000. Billed as the "finest hotel on the Carolina coast," it was financed by the Nags Head Hotel Corporation, made up of W.C. Dawson, Frank K. Dawson and Haywood Duke, from Elizabeth City. The three-story hotel, with cedar shake exterior, measured 150 by 34 feet, excluding the wide porches.

Original plans for the Nags Header included a lifeguard and a full-time nurse to watch children of hotel guests. A popular taproom, with a jukebox, was on the bottom level of the Nags Header, where patrons enjoyed the great jitterbug songs of the day. George C. Culpepper, also from Elizabeth City, owned the hotel from 1944 to 1970.

During the late 1960s and early 1970s, music continued in the taproom, which increasingly became a hangout for young locals and college students working in restaurants for the summer. Acoustic folk rock and blues filled the taproom, with its concrete floor and opened shuttered windows without glass or screens. Randy Friel played a steady gig there at that time. "Beer was cheap, and everybody knew each other. You could walk in with sand on your shoes and not worry about it," he remembers.

By the mid-1970s, the Nags Header had been closed and was condemned. On the morning of October 28, 1978, a fire broke out on the third floor and quickly spread, destroying the fifty-year-old landmark. The Nags Head Beach Club building was moved off of its oceanfront lot and has been converted into a bed-and-breakfast in Nags Head.

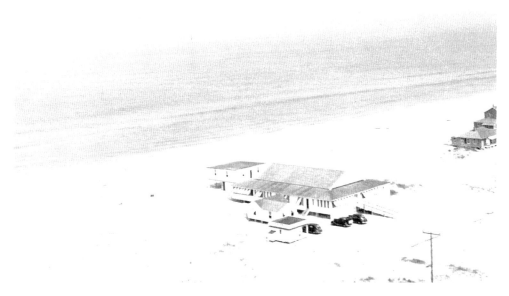

Aerial view of the Nags Head Beach Club, which stood near the present day Bonnet Street beach access. *Photo by Aycock Brown, Outer Banks History Center, 1950.*

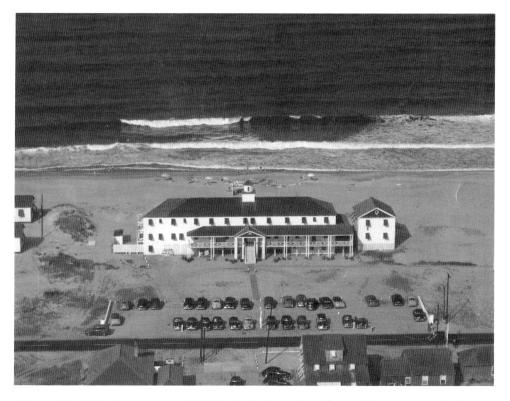

Windsor, North Carolina contractor G.C. Mizelle built the Nags Header. The lumber and bricks used for the three-story hotel came from Elizabeth City's Chesson Manufacturing Company and the Elizabeth City Brick Company. *Photo by Roger P. Meekins, Outer Banks History Center, 1950.*

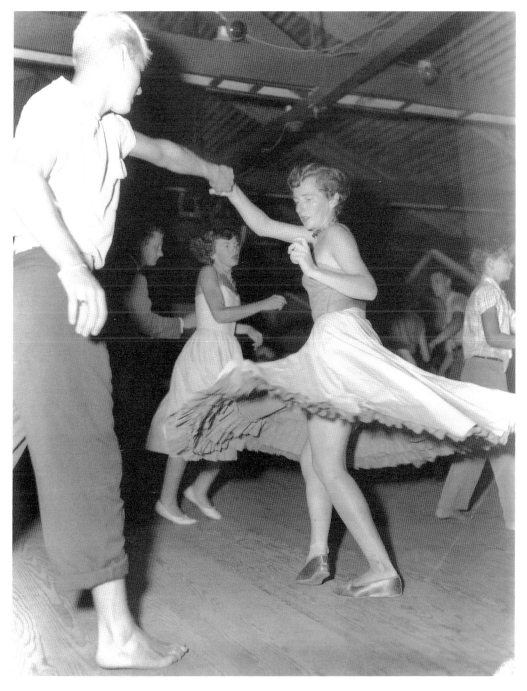

Dancers in the rustic Nags Head Beach Club. *Photo by Aycock Brown, Outer Banks History Center, circa 1954.*

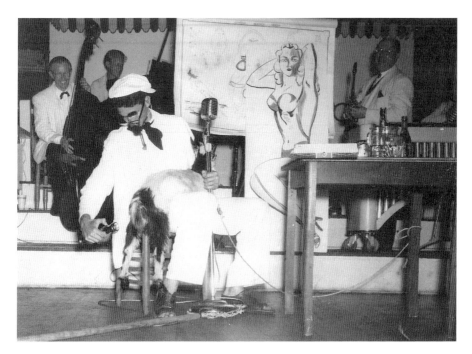

For a time, the Nags Header had a resident goat named Bill to keep the lawn trimmed. Owner George Culpepper believed it was more efficient than a mower. Bill seems to have been pressed into service during a late-night comedy act. *Photo by Roger P. Meekins, Outer Banks History Center, 1949.*

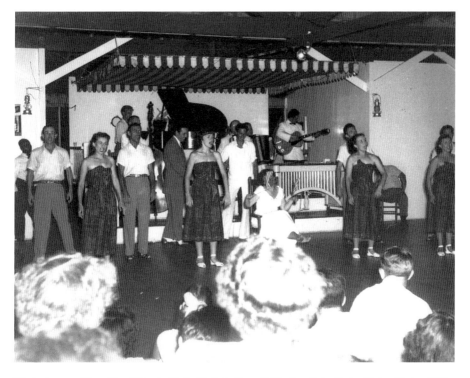

Musical revue, Nags Head Beach Club. *Photo by Roger P. Meekins, Outer Banks History Center, 1949.*

A barefooted stand-up performer at the Nags Head Beach Club. Notice the life-ring decoration in the background. *Photo by Aycock Brown, Outer Banks History Center, date unknown.*

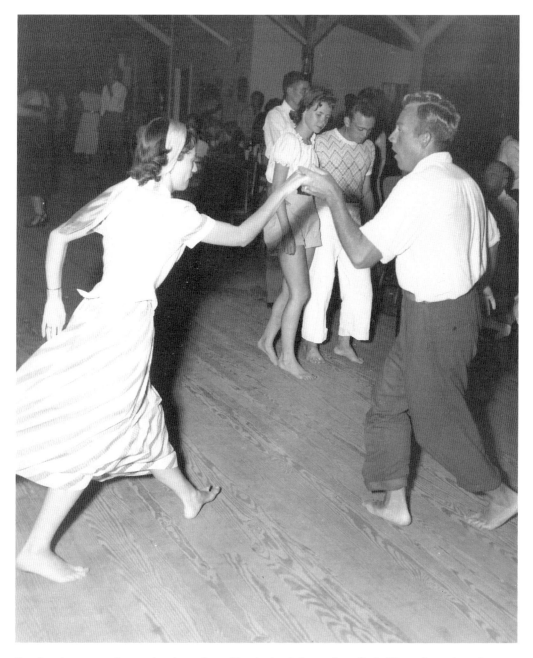

Barefoot dancers on the wooden dance floor. *Photo by Aycock Brown, Outer Banks History Center, date unknown.*

Rear view of the Nags Header, taken from the beach. *Photo by Aycock Brown, Outer Banks History Center, date unknown.*

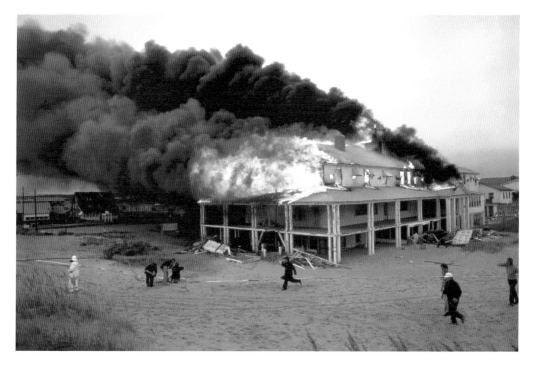

The conflagration that claimed the Hotel Nags Header. *Photo by Ray Matthews, 1978.*

The Nags Head Casino

The Nags Head Casino is, undoubtedly, the most remembered landmark of the Outer Banks. During its tenure as an entertainment center and dance hall, thousands of people filed through its doors to jitterbug, shag or twist the night away on the polished wooden dance floor. It is deeply ingrained in the memories of both its patrons and employees.

The two-story, white, wooden structure was built on the Beach Road in the early 1930s in front of Jockey's Ridge. One of its first uses was to house stonemasons who were constructing the Wright Brothers National Memorial. By the mid-1930s, men of Camp Kitty Hawk, a Works Progress Administration (WPA) transient labor camp, called the building home. It was dubbed the Casino shortly after Manteo's George Thomas "Ras" Westcott Jr. purchased it in 1937, which began a legacy that would last for over thirty-five years.

During Westcott's tenure, downstairs offered duckpin bowling, pool tables, pinball machines and a snack bar that served up hamburgers, hot dogs and fountain drinks. But music and dancing upstairs was the Casino's main attraction.

The Casino hosted some big name bands and the crowds to go with them. Big Band leaders brought their orchestras–Artie Shaw, Sammy Kaye, Duke Ellington, Tommy Dorsey and the like. Louis Armstrong performed at the Casino, as did Fats Domino. During the 1960s, bands changed with the times, and groups such as the Showmen, the Beach Nuts, the Mad Hatters and the Rhondells played for crowds, who continued to make the Casino a happening nightspot.

Stories are legion regarding the Casino's second-floor windows, which were propped open during the summer to allow the ocean breezes in. They occasionally became escape routes for rowdy revelers who didn't want to meet up with Ras, one of his bouncers or Nags Head Police Chief Donnie Twyne. Regulars knew that it was best not to park under the windows, to keep their cars free from damage that might be caused by a jumping patron.

Boxing was another event held at the Nags Head Casino. Once a week, a boxing ring was assembled in the middle of the dance floor, where fighters (usually local boys against soldiers and sailors from Norfolk, Quantico or Fort Bragg) could duke it out. Winners received five dollars, and according to Ray Jones of Nags Head, who participated in some fights, "losers didn't get anything but sore eyes and a beat-up head."

The Ash Wednesday Storm of March 1962 damaged the Casino. Its roof finally collapsed after a winter storm in the mid-1970s, after Wescott had already sold the building.

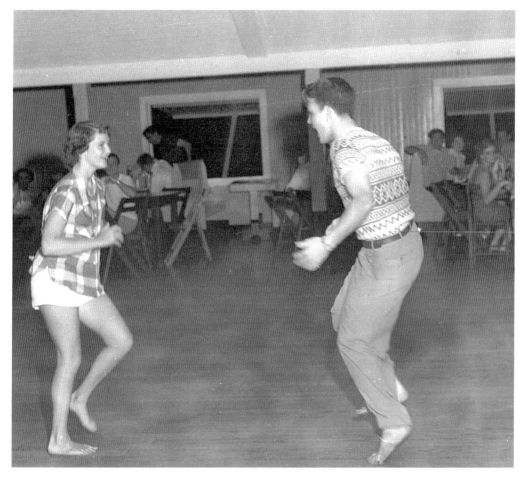

Dancers at the Casino. A jukebox also provided music for dancing in between sets or on nights without a live band. *Photo by Aycock Brown, Outer Banks History Center, circa 1955.*

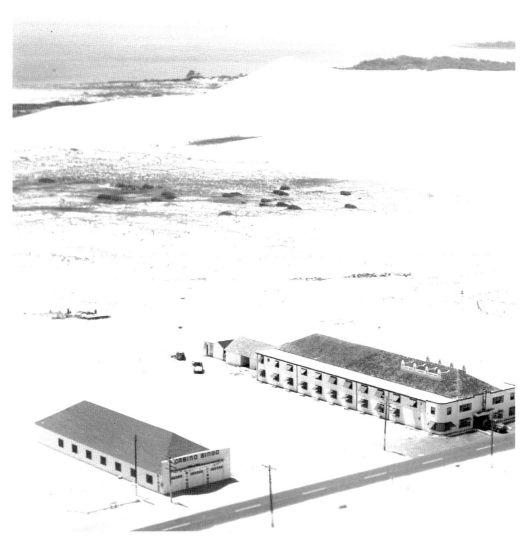

Aerial view of Casino Bingo and the Nags Head Casino. Crowds of one thousand people were not uncommon during special events. The upstairs dance hall would often become so crowded that the floor would sway. *Photo by Roger P. Meekins, Outer Banks History Center, 1950.*

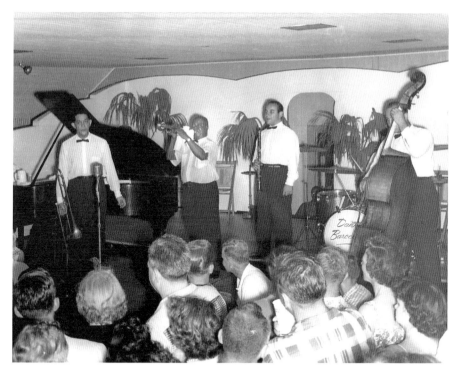

Louis Armstrong at the Casino. *Photo by Aycock Brown, Outer Banks History Center, 1958.*

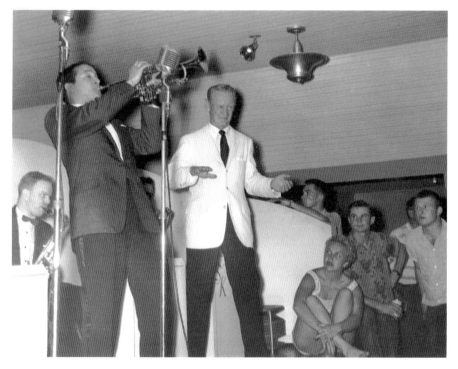

"Swing and sway with Sammy Kaye" was this popular bandleader's slogan. *Photo by Aycock Brown, Outer Banks History Center, circa 1958.*

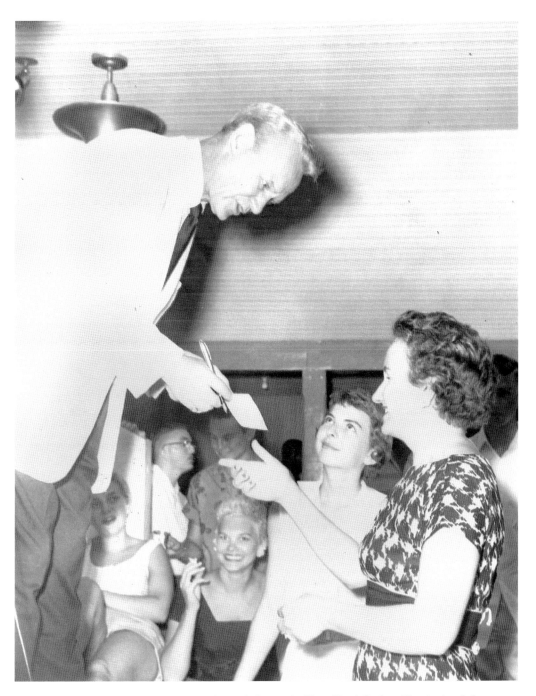

Sammy Kaye signs autographs during an intermission at the Nags Head Casino. *Photo by Aycock Brown, Outer Banks History Center, circa 1958.*

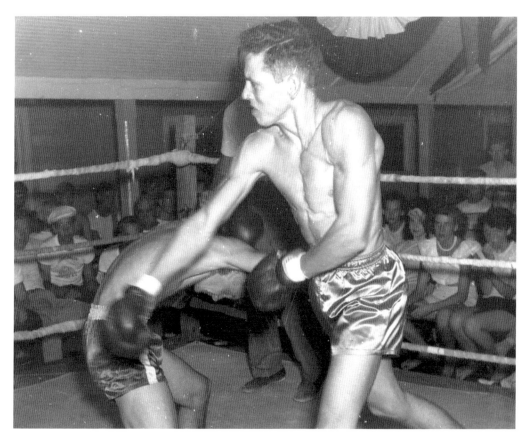

Weekly boxing matches between locals and servicemen were popular draws at the Casino. *Photo by Roger P. Meekins, Outer Banks History Center, circa 1954.*

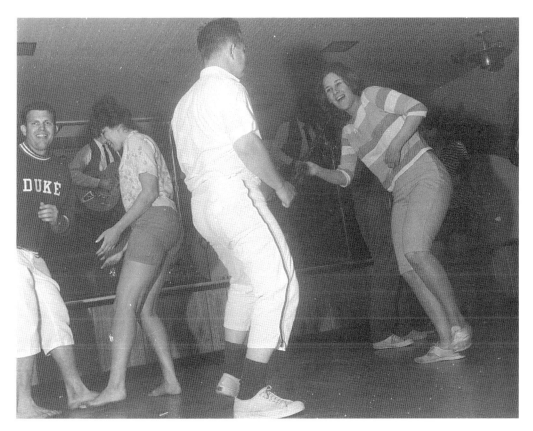

Twisters at the Nags Head Casino. *Photo by Aycock Brown, Outer Banks History Center, circa 1962.*

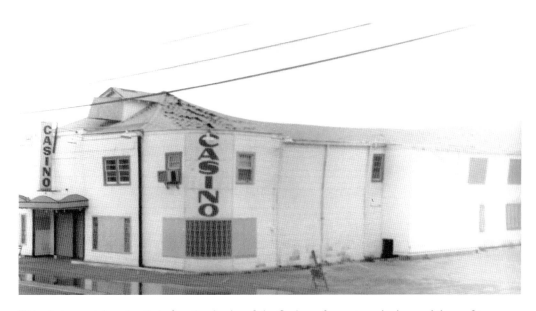

This photo was taken shortly before the demise of the Casino, after a storm had caused the roof to collapse. *Photo by Aycock Brown, Outer Banks History Center, circa 1975.*

The Carolinian Hotel

The Carolinian Hotel was one of the first hostelries to open on the Outer Banks during the post–World War II building boom. It began hosting visitors in June 1947. The Carolinian was owned by the Carolinian Hotel Corporation, made up of Guy Lennon and siblings Wayland Sermons, Lucille Sermons Purser and Lima Sermons Oneto. Lucille and Lima managed the hotel, along with Lima's husband, Julian Oneto. The late Carl Nunemaker, former mayor of Nags Head, was fond of saying that the white concrete Carolinian Hotel helped to put Nags Head on the map.

The Carolinian's success grew in part because of the special events held in its Dogwood and Driftwood Rooms. Fashion shows were often held indoors or poolside. Hotel guests enjoyed lifeguarded beaches, children's activities, such as watermelon parties and scavenger hunts, and live music and dancing in the evenings for the adults.

In addition to the Carolinian's Dogwood Room and Driftwood Room, there was the Anchor Club on the lower level, an area large enough to host a crowd. It was a favorite place for groups to hold meetings and conventions–the North Carolina Travel Council, Tri-State Medical Society, Business and Professional Woman's Society and the North Carolina State Highway Commission, to name a few. Something was always going on at the Carolinian.

Early on, the Carolinian hosted a Valentine's Day Fox Hunt to attract visitors to the beach during the off-season. On the morning of the hunt, the hounds were released, but instead of hunters chasing the pack on horseback, the dogs were followed by hunters in jeeps and other assorted four-wheel-drive vehicles. Eventually moved to the spring, the fox hunt was held annually until 1972, when growing opposition by animal rights activists and greatly reduced open areas for hunting brought it to an end.

James Pace held art classes at the Carolinian in the late 1950s, which culminated in a Summer Art Show. Local conservationist, developer and former magazine illustrator Frank Stick exhibited his watercolors of fishes in 1966, in conjunction with the Nags Head Fishing Tournament. In the 1970s, small cast comedies were performed by traveling troupes during the off-season.

The Carolinian was eventually sold, and it fell into various states of disrepair over the years. After most of the building's contents were auctioned off, it was demolished in 2001.

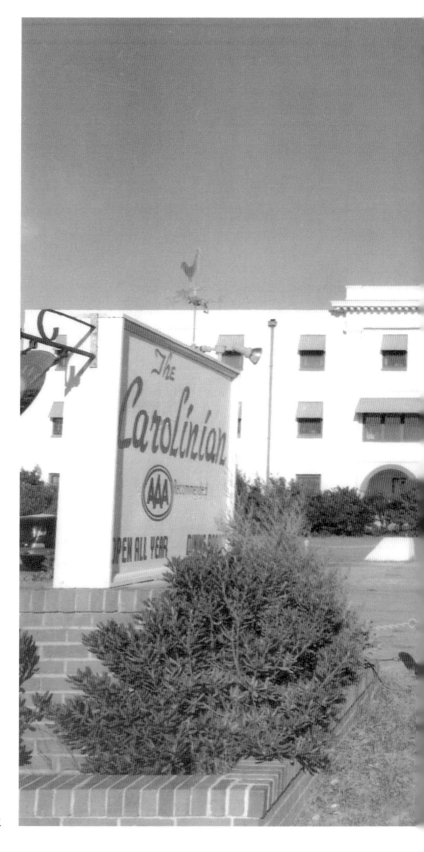

The stately Carolinian Hotel during its early years, when it symbolized the growth of the tourist industry on the Outer Banks. *Photo by Aycock Brown, Outer Banks History Center, 1956.*

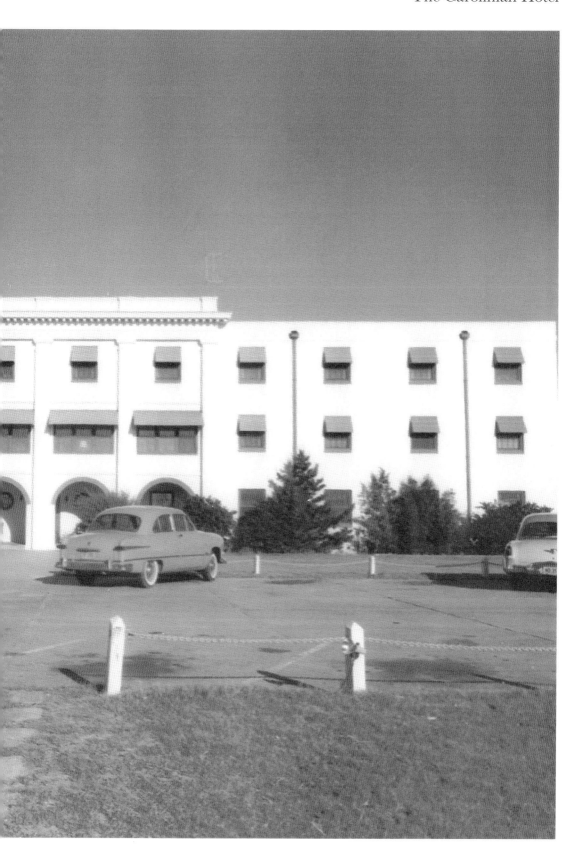

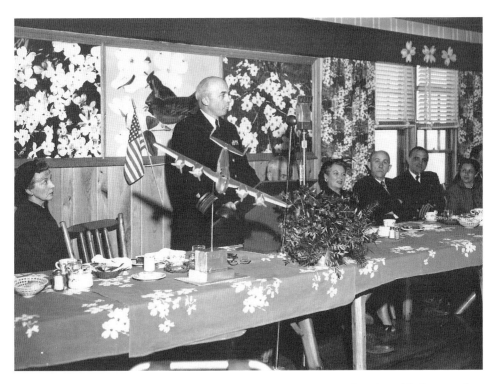

A banquet in the Dogwood Room of the Carolinian, most likely in conjunction with the annual commemoration of the Wright brothers' first flight. *Photo by Aycock Brown, Outer Banks History Center, date known.*

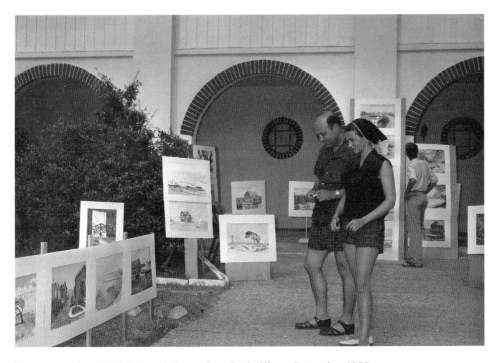

Summer art show. *Photo by Aycock Brown, Outer Banks History Center, circa 1958.*

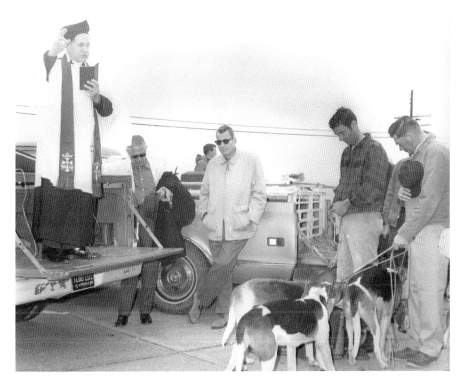

The Blessing of the Hounds before the annual Valentine's Day Fox Hunt. *Photo by Aycock Brown, Outer Banks History Center, circa 1958.*

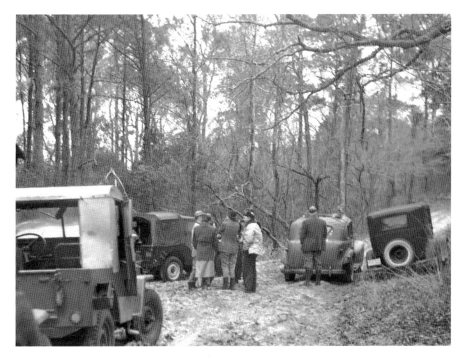

Hunters wait while the hounds pursue the fox during the inaugural hunt in either Nags Head Woods or Colington. *Photo by Aycock Brown, Outer Banks History Center, 1949.*

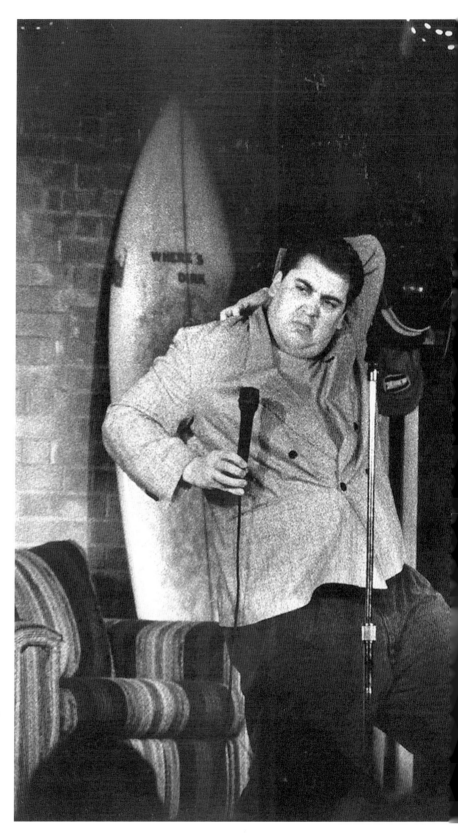

During the Carolinian's last years, the Comedy Club, Inc. operated in the former Anchor Room, where up-and-coming comedians brought laughs to vacationers. Mark Petrucelli entertains the crowd. *Photo by Drew C. Wilson, Outer Banks History Center, 1990.*

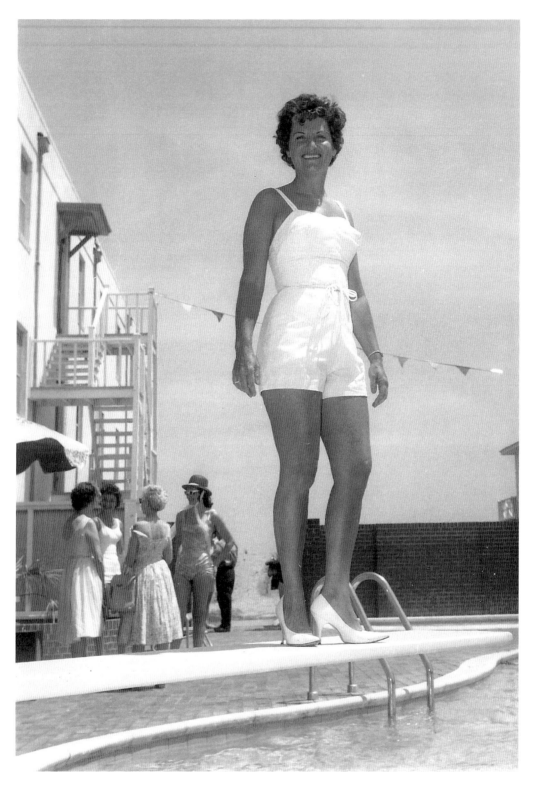

An Outer Banks beauty models a bathing suit at a poolside fashion show. *Photo by Aycock Brown, Outer Banks History Center, circa 1958.*

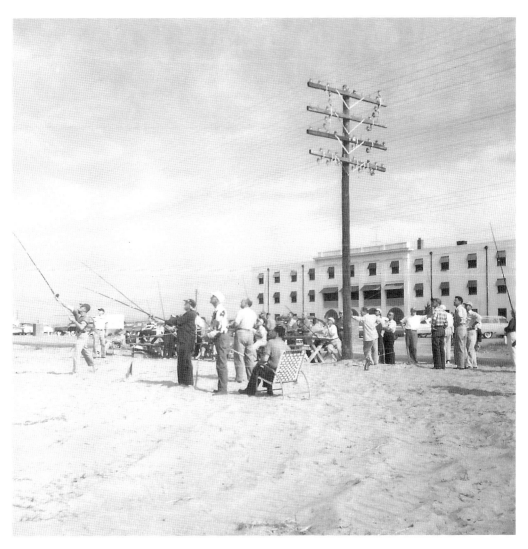

A surfcasting lesson. *Photo by Aycock Brown, Outer Banks History Center, 1953.*

The Pirate's Jamboree

The Dare Coast Pirate's Jamboree was organized in 1955 as an event to jump-start the tourist season by attracting a preseason spring crowd to the Outer Banks between Easter and Memorial Day. The Nags Head Fishing Tournament, launched in October 1950 by the Nags Head Surf Fishing Club, had already begun to extend the season into the fall.

Lucille Winslow of the Carolinian Hotel was one of the key organizers of the inaugural three-day event that took place April 29 through May 1, 1955. Over time, the event grew to a weeklong happening and then expanded to a four-week "Jamborama" in 1963.

Just after the Christmas holidays, the men of Dare County would grow beards, and women would sew pirate costumes. Organizers traveled to local North Carolina towns, and to cities as far away as Washington, D.C., Pittsburgh and Cincinnati, to promote the Pirate's Jamboree and the Outer Banks in general.

During the Jamboree, events were held at Hatteras, Nags Head and Manteo, including frog jumping contests, flower shows, kid's games, boat races, fishing tournaments, costume contests, parades, lifesaving demonstrations, beach buggy races and dances. The culminating event was the crowning of the pirate king and queen at the Pirate Ball, usually held at the Nags Head Casino.

It is frequently said that the Dare Coast Pirate's Jamboree died of its own success. Each year, crowds grew larger and larger, and they were often a burden to the area's few law enforcement officials. Furthermore, the pirate theme led to an atmosphere of rowdiness. The event was successful in bringing an early season crowd to the Outer Banks; however, there were other factors that caused the Jamboree's demise.

Dedicated organizers worked diligently for years to pull off the annual event, but toward the end (the Pirate's Jamboree was held each year from 1955 to 1964) many businesses were reaping the economic benefits of the Jamboree without doing any of the work associated with the planning and preparations.

During a mock pirate battle in 1963, the marsh across from the Manteo Waterfront (now Roanoke Island Festival Park) was ignited and caught fire. This is a prime example of an event gone awry at the Dare Coast Pirate's Jamboree.

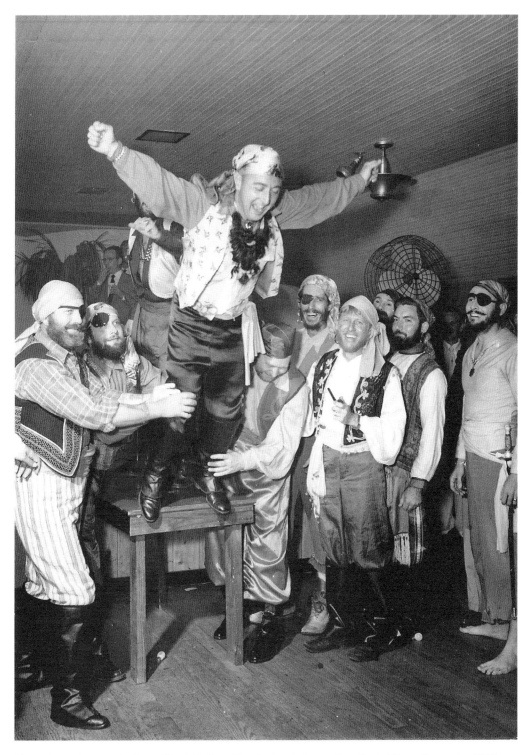

Pirate shenanigans at the Nags Head Casino. *Photo by Aycock Brown, Outer Banks History Center, circa 1960.*

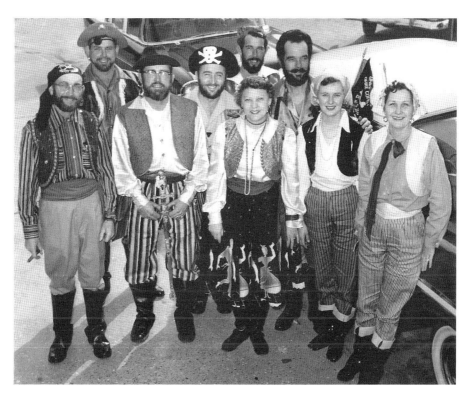

Dare County pirates show off their costumes. Delegations were sent to nearby towns, as well as distant cities, to promote the Pirate's Jamboree. *Photo by Aycock Brown, Outer Banks History Center, circa 1958.*

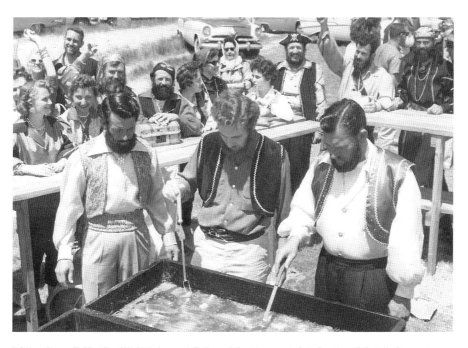

Miller Gray, E.H. "Duff" Shinke and Edison Meekins cook fish for the "World's Largest Saltwater Fish Fry." *Photo by Aycock Brown, Outer Banks History Center, 1960.*

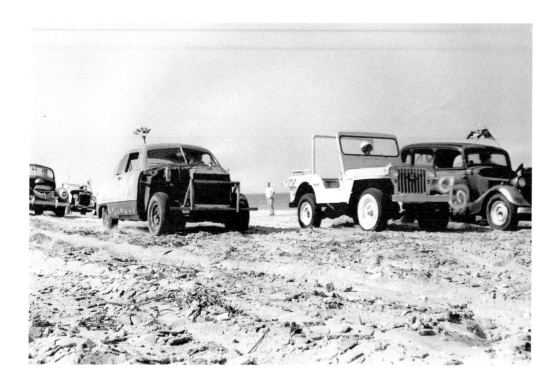

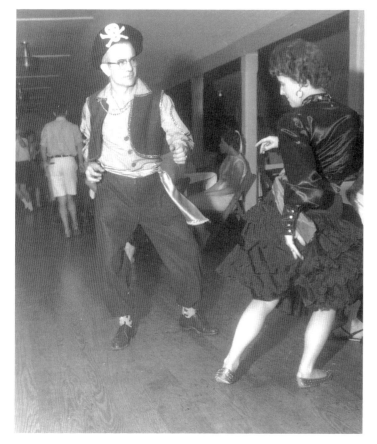

Above: Many families on Hatteras Island had an old, unregistered vehicle that was only used for beach driving. These were souped up and used in the beach buggy races. *Photo by Aycock Brown, Outer Banks History Center, circa 1960.*

Left: Ralph Swain and an unidentified woman at a Pirate Ball at the Nags Head Casino. *Photo by Aycock Brown, Outer Banks History Center, circa 1960.*

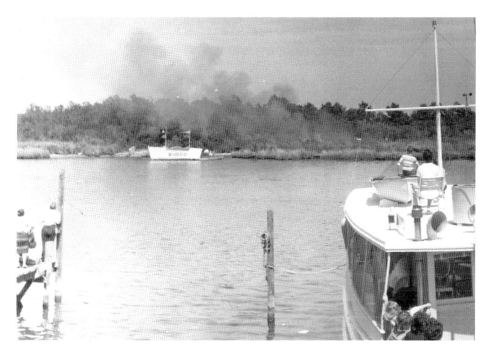

Cannon fire set the marsh across from downtown Manteo ablaze during a mock pirate battle in 1963, causing Pirate's Jamboree organizers to consider canceling the event. *Photo by Aycock Brown, Outer Banks History Center, 1963.*

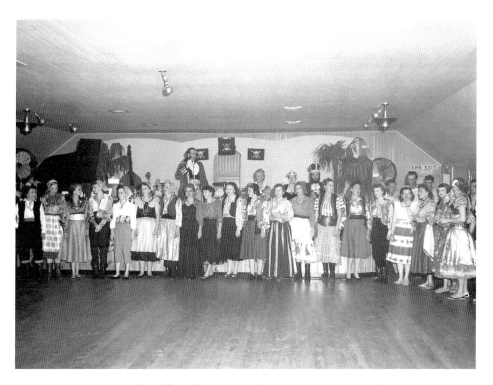

A pirate gathering at the Nags Head Casino, most likely a costume contest. *Photo by Aycock Brown, Outer Banks History Center, circa 1958.*

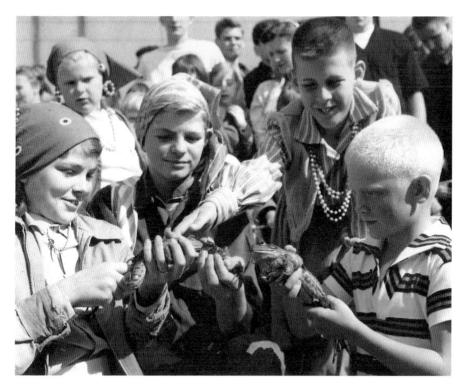

The Jamboree included several events for children and teens. These Kitty Hawk kids check out the frogs for the frog jumping contest. *Photo by Aycock Brown, Outer Banks History Center, circa 1958.*

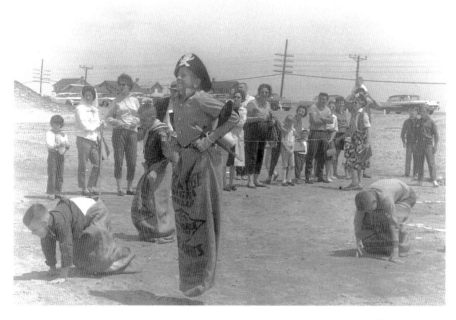

Young buccaneers take part in a sack race. *Photo by Aycock Brown, Outer Banks History Center, circa 1962.*

The Arlington Hotel and the Sea Fare Restaurant

The Arlington Hotel began on the Nags Head sound-side as Modlin's Hotel, but after the Virginia Dare Trail was built, the hotel was moved to the oceanfront near Milepost 14 in Nags Head. In 1944, it was purchased by Dewey and Phoebe Hayman. Mrs. Hayman was no stranger to the hospitality business. Her father, Nathaniel Gould, had owned and operated the Tranquil House on Roanoke Island.

The building's original portion had dormer windows and porches all around. A flat-topped wing on the north side was added in the early 1950s. Meals were served in the Arlington's oceanfront dining room. Of course, seafood was the specialty. Waiters dressed in scarlet jackets attended to diners' every need.

During the 1950s, one of the Arlington's cottages was converted into a playhouse for visiting, socializing or playing cards or games. One room was set up for children's activities.

In 1959, the Haymans opened the Sea Fare Restaurant directly across the street from the Arlington. Dewey and Phoebe's son Mike bought the restaurant in 1966 and immediately began expanding it. The Sea Fare was one of the first places with enough seating for large formal banquets, and many parties and community events took place there, from pre-prom dinners to fashion shows and fishing banquets.

Mike Hayman was known for running a tight ship and was legendary for his discipline, which we would define as "tough love" by today's standards. The Sea Fare was sold in 1983 and was renamed the Sea Farer. The building caught fire and tragically burned on August 23, 1984. Lost in the blaze were several pieces of Wright brothers memorabilia that had been collected by Rick Young, who managed the Sea Farer and its Wright Cycle Lounge.

Although the Arlington catered to guests for decades, the final blow to the aging structure was a fierce winter storm in 1974. Storm tides undermined the center portion of the building, causing it to collapse.

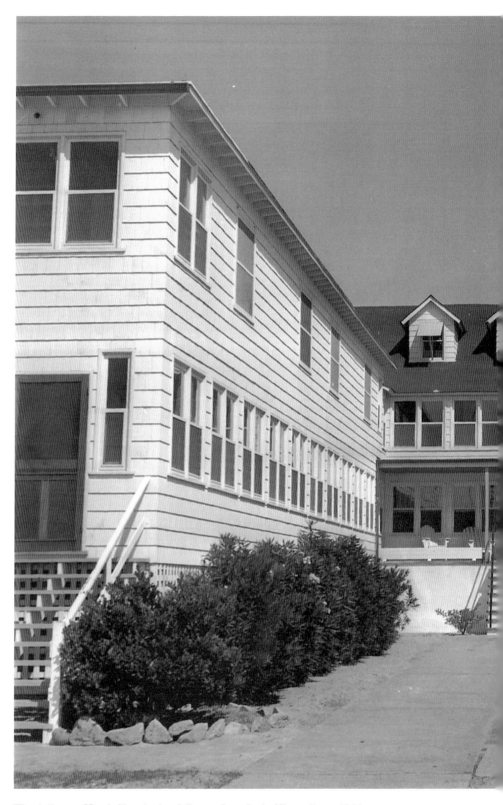

The Arlington Hotel. *Photo by Aycock Brown, Outer Banks History Center, 1954.*

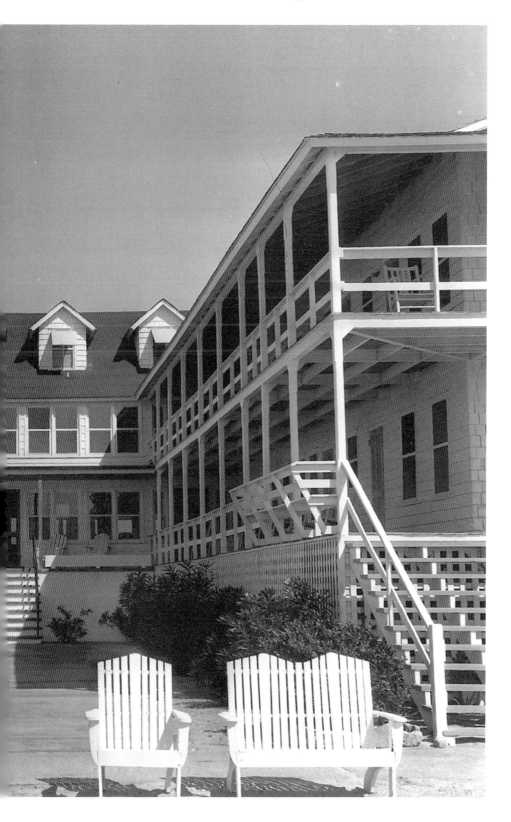

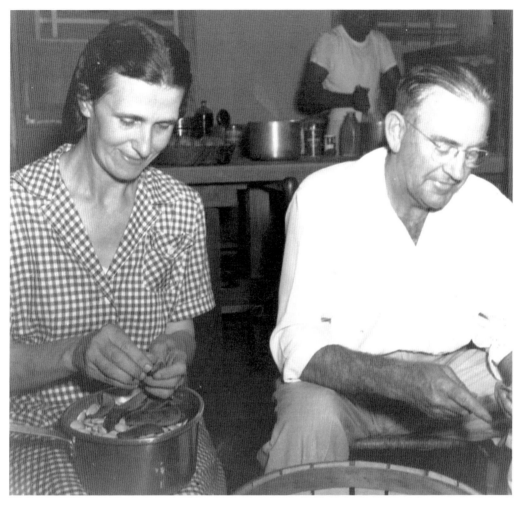

Phoebe and Dewey Hayman shelling peas at the Arlington Hotel. *Photo by Roger P. Meekins, Outer Banks History Center, circa 1954.*

The lounge of the Arlington Hotel. *Photo by Aycock Brown, Outer Banks History Center, circa 1954.*

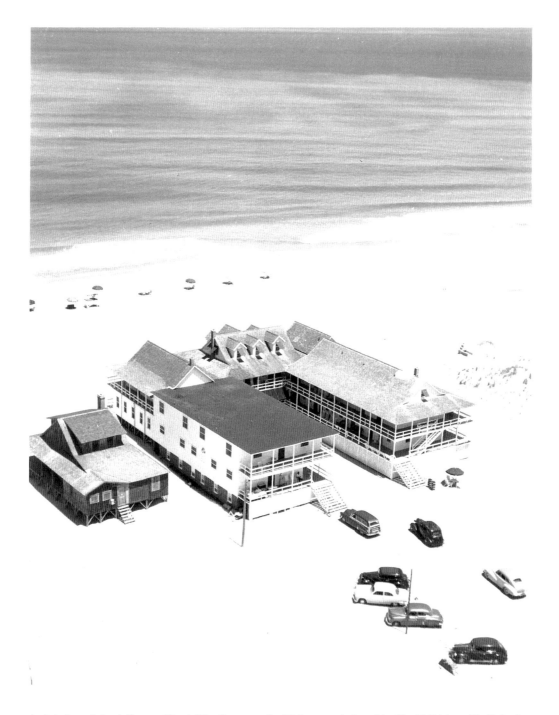

Aerial view of the Arlington Hotel. The flat-topped addition was designed by David Stick and built in the early 1950s. *Photo by Roger P. Meekins, Outer Banks History Center, 1950.*

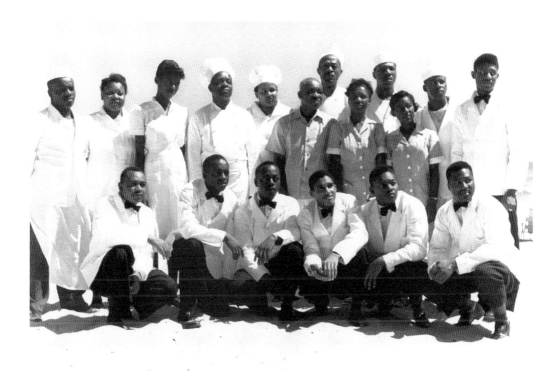

Above: Kitchen and wait staff of the Arlington Hotel. *Photo by Roger P. Meekins, Outer Banks History Center, circa 1950.*

Right: Young ladies enjoy the ocean breeze on one of the Arlington's covered porches. *Photo by Aycock Brown, Outer Banks History Center, circa 1954.*

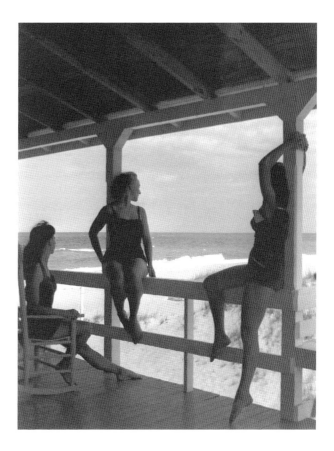

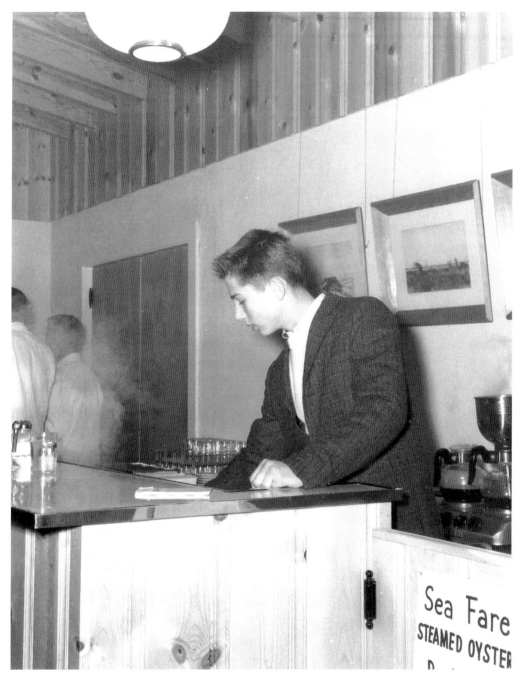

Mike Hayman, who would later buy the Sea Fare Restaurant from his parents. *Photo by Aycock Brown, Outer Banks History Center, 1959.*

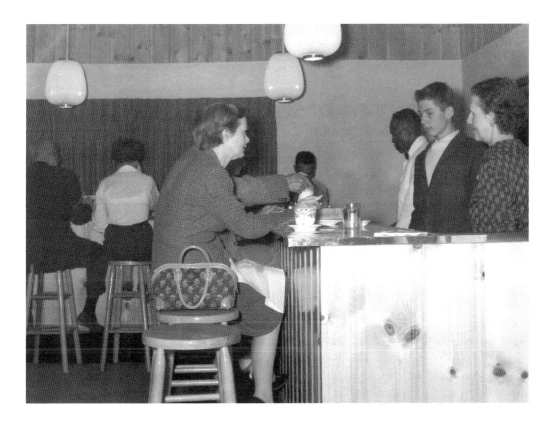

Above: Sea Fare Restaurant, with Phoebe and Mike Hayman behind the bar. *Photo by Aycock Brown, Outer Banks History Center, 1959.*

Right: Dewey Hayman inspects oysters to serve at the Sea Fare. *Photo by Aycock Brown, Outer Banks History Center, 1959.*

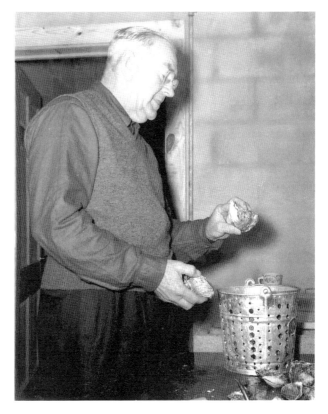

Mann's Recreation Center

In the late 1940s, an entertainment hub began to emerge when Gaston Mann built the Nags Head Pier, first known as Mann's Ocean Pier. Two flat-topped concrete buildings were constructed just south of the pier, and at that time they were referred to in deeds as Ocean Shores Recreation Center.

The chain of title is difficult to follow; however, Mann and his wife owned the northernmost building for many years, during which time it was known as Mann's Recreation Center. Both structures housed many amusement establishments, run by a long list of leaseholders and managers.

Mann's Recreation Center was billed as "a fine place for the whole family," boasting amusements and dancing, refreshments, picnic tables, a bathhouse, a private beach with lifeguards, skating, bowling and carpet golf. Jones Bingo and Al's Surfside Bingo operated out of the recreation center in the 1950s. By 1966, Gaston Mann had passed away, and his wife and son Bryan became owners.

The northern building continued as the recreation center and was later managed by Fred Jones and a Norfolk partner in the amusement machine business. It then became the Foosball Palace. For years, Jones ran the popular arcade that was "the biggest hangout on the beach for kids." Jones saw many of the young patrons grow up. He was a father figure in a way, barring them from the establishment if they created trouble, but allowing them back after they had served a sufficient "time-out" period. There was a humorous saying amongst locals, "You're alright. I don't care what they say about you at the Foosball Palace."

The southern building became a series of nightclubs–the Twist Lounge (probably gaining another moniker around the time Chubby Checker's dance craze "the Twist" was popular), Oz, the Other Place and, finally, the Atlantis. Jeanne Wade of Kill Devil Hills recollected:

> It was the perfect beach bar. A nice ocean breeze, a wooden dance floor, a cool stage, and a bar with easy access to bartenders. It was more than that. It was the aura or something around it that screamed —Vacation! Summer! Dance! Everybody in there always seemed to have a great party attitude. The first time I saw someone do "The Flounder" was in there.

Live music, dancing, shooting pool and wet T-shirt contests were all part of the Atlantis mystique. My husband, who stands five feet, five inches tall, remembers the wet T-shirt contests, but he usually got shuffled to the back of the large crowd, where he occasionally caught a glimpse of a contestant's head. Manager Mike McQuillis didn't tolerate disorderly conduct, having plenty of adept bouncers on hand to quickly escort any rowdy customers to the door.

On Sunday afternoons during the summer, the Atlantis offered volleyball and cold beer, which was renamed "volley beer and cold ball" by local patrons. These gatherings were held on the beach behind the building and were a nice way to get outdoors, spend time with friends and wind down the weekend.

In the final years, the Atlantis seemed to hold an aroma of beer, stale cigarette smoke and urine that oftentimes overcame this type of establishment. The concrete floor, regularly doused with beer, gave the building a damp feel. The Atlantis and the Foosball Palace were razed in the late 1990s.

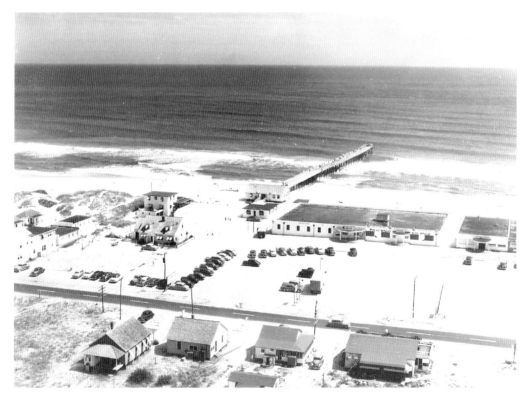

Aerial view of the Nags Head Pier and the Recreation Center. *Photo by Roger P. Meekins, Outer Banks History Center, circa 1950.*

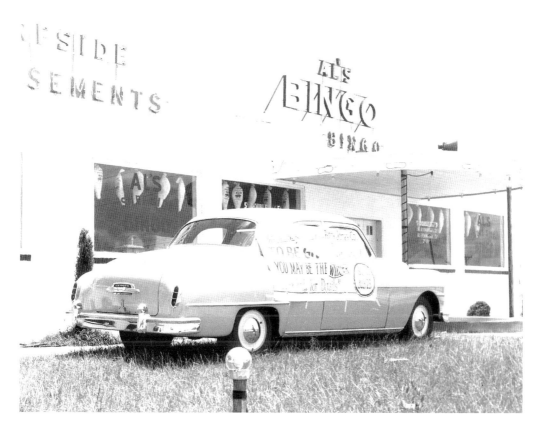

As a special promotion, Al's Bingo gave away a DeSoto as the grand prize on July 23, 1950. According to a former employee, "The place was packed that night." *Photo by Roger P. Meekins, Outer Banks History Center, 1950.*

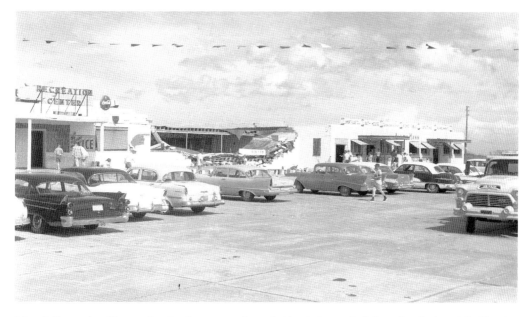

Mann's Recreation Center, shortly after a tornado peeled back the roof of the roller-skating rink. *Photo by Aycock Brown, Outer Banks History Center, 1959.*

Neon signs light up
Al's Bingo at night.
*Photo by Roger P.
Meekins, Outer Banks
History Center, 1950.*

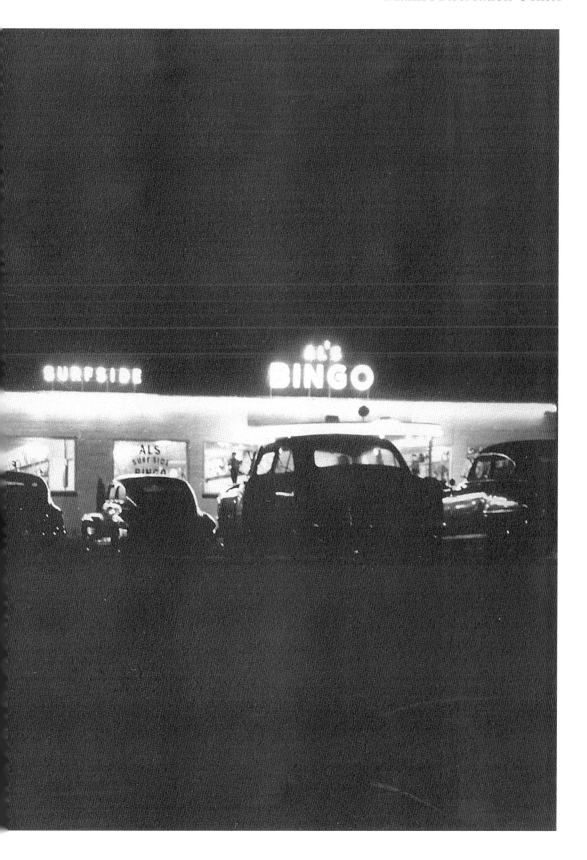

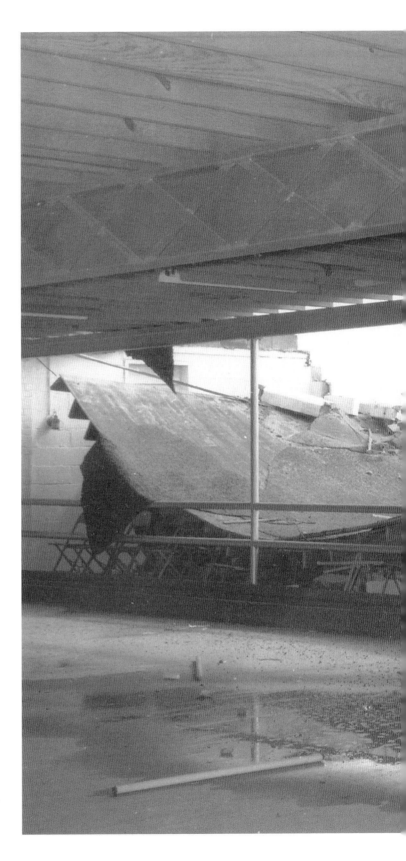

Interior view of the tornado damage to the roller-skating rink at Mann's Recreation Center. *Photo by Aycock Brown, Outer Banks History Center, 1959.*

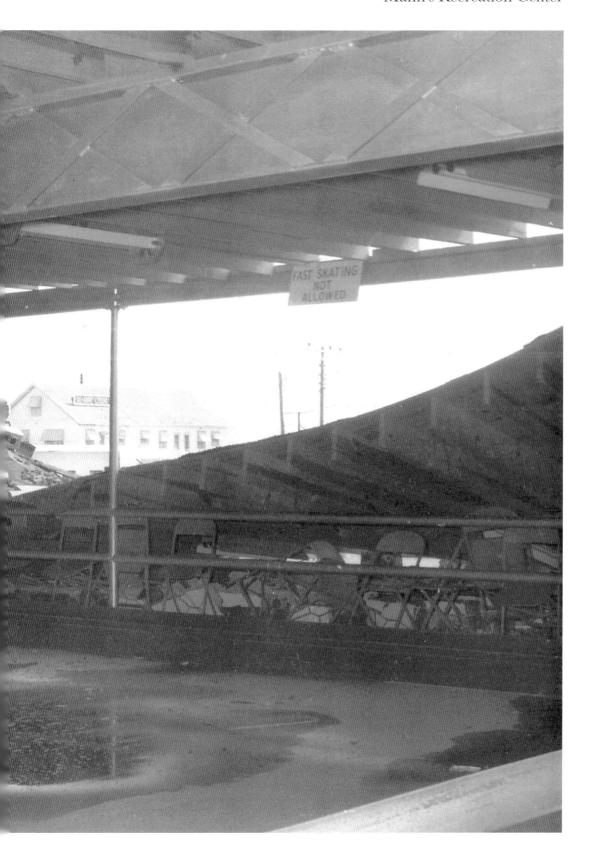

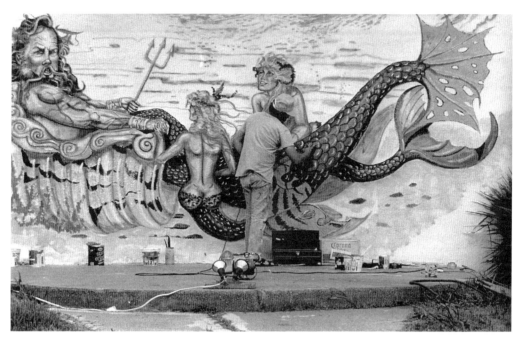

Kelly Guthrie of Atlantic Beach, North Carolina, painted a mural of King Neptune and mermaids on Atlantis's façade. *Photo by Drew C. Wilson, Outer Banks History Center, 1990.*

Brad McGetrick, Kimberly Pittman, Sue Conolly and Bob Brown spent some time at the Atlantis on their spring break. *Photo by Drew C. Wilson, Outer Banks History Center, 1992.*

The Circus Tent

The Circus Tent was a familiar sight on the bypass, south of the Wright Memorial in Kill Devil Hills, from 1968 to 1988. This interdenominational ministry began in 1965, when movies were shown on a makeshift wooden screen in front of the Kill Devil Hills Coast Guard Station. The films were so popular with summer visitors that the Circus Tent was later established and featured an ice cream parlor and nightly folk musical revues. Folding chairs were arranged around tables made from old cable spools, where patrons could relax in a laid-back atmosphere and enjoy the free concerts. During its heyday, five hundred people a day visited the Circus Tent.

The New Hermeneutics, made up of college students and young adults, performed one afternoon and three evening shows. On Monday nights, regional acts from North Carolina and Virginia traveled to take the stage at the Circus Tent. In 1971, the mission grew to include a prayer garden. Manna Christian Bookshop was added in 1972, and a Christian Day Camp was offered in 1977.

Plans were launched for the Circus Tent to go mobile in 1974. The idea was to create a Mississippi River–style showboat that would cruise the waters of the sound with a troupe, a minister and a lay teacher. While the showboat never materialized, the idea for mobilization did. Circus Tent puppeteers traveled to campgrounds, motels and nursing homes and used puppets to share their message of the Good News.

Crowds at the Circus Tent began to dwindle during the mid-1980s with so many new attractions and additional places for evening entertainment. The Circus Tent closed up shop after the 1988 season, but the mission continued as Creative Puppet Ministries and today still spreads the Gospel as Creative Ministries, Inc.

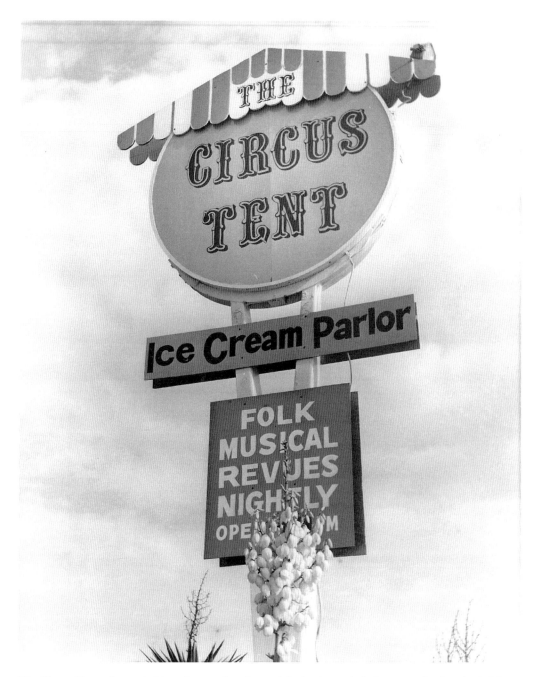

The Circus Tent welcomed visitors for two decades, and during its peak, it drew over five hundred visitors a day. *Photo by Aycock Brown, Outer Banks History Center, circa 1970.*

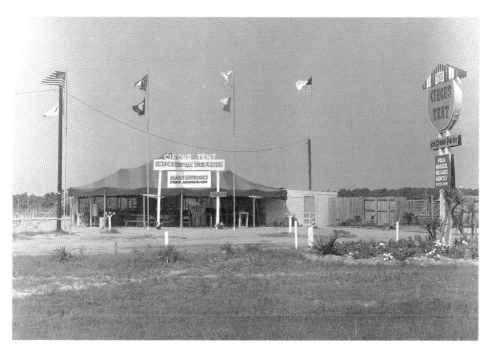

The Strongman Milkshake, Fire Eater Special and the Fat Lady Sundae were some of the ice cream treats available at the Circus Tent. Some sundaes were made from six or nine scoops of ice cream and meant for a family or group of friends to share. *Photo by Aycock Brown, Outer Banks History Center, 1970.*

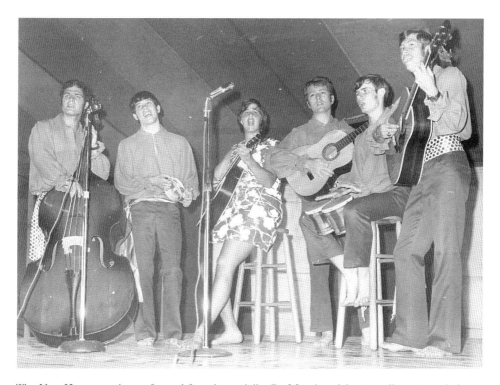

The New Hermeneutics performed four shows daily. On Monday nights, traveling acts took the stage at the Circus Tent. *Photo by Aycock Brown, Outer Banks History Center, circa 1968.*

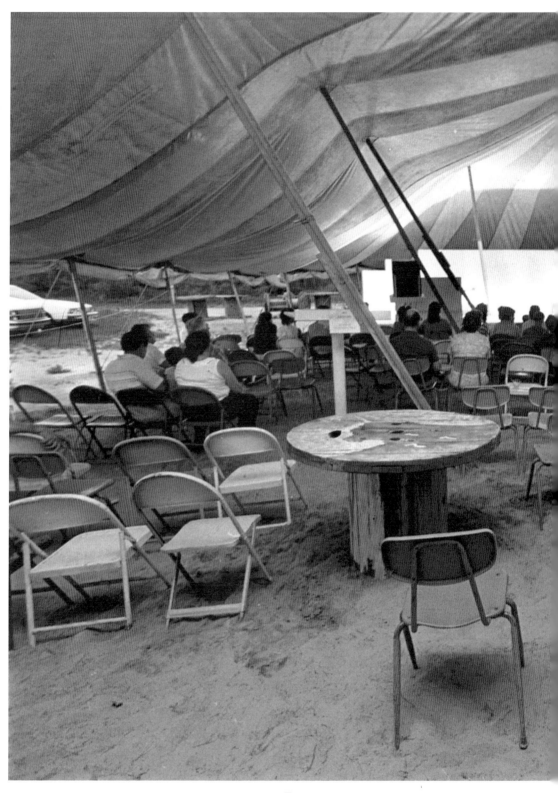

By the 1980s, crowds at the Circus Tent began to wane. *Photo by Drew C. Wilson, Outer Banks History Center, 1986.*

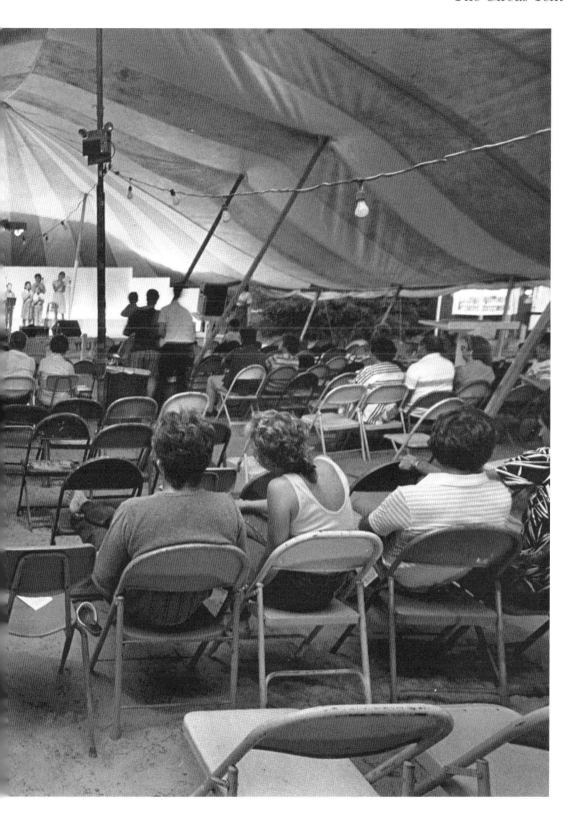

Left: The theme of the prayer garden at the Circus Tent was "God in Creation, Man in Response." It won nine state and national awards for its imaginative arrangement. *Photo by Aycock Brown, Outer Banks History Center, circa 1972.*

Below: One of the traveling puppet show performances put on by the Circus Tent. *Photo by Aycock Brown, Outer Banks History Center, date unknown.*

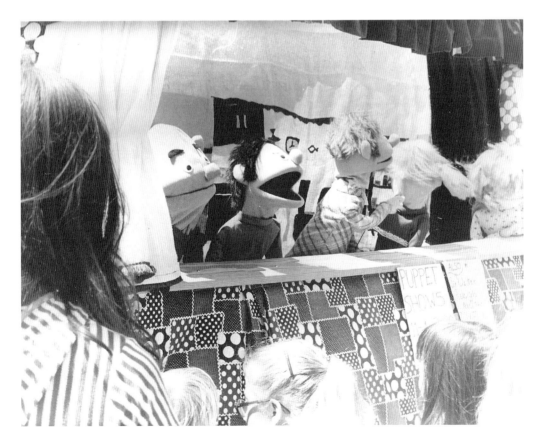

The Galleon Esplanade

The Galleon Esplanade was the creation of entrepreneur extraordinaire George Crocker, who came to the Outer Banks and opened the Beacon Motor Lodge and then the Cabana East Motel on Beach Road at Milepost 10.5. During the 1960s, Crocker leased a small sportswear shop across from his motels, which he called Trott's Galleon the first season. The next year, the establishment was known simply as the Galleon.

Crocker found that he enjoyed selling women's clothing, and he expanded offerings to include men's clothing and gifts. Early on, the shop was grossing $12,000 a year, but Crocker confidently increased his stock and spent nearly $20,000 on merchandise. After experiencing several successful seasons, he purchased the shop and three additional adjacent lots and immediately enlarged retail space by converting a small living area in the rear of the store.

The astute businessman became ensconced in all that went along with running the store. He would travel to trade shows to select the perfect clothing and gifts to sell at the Galleon, and he would then spend long hours unpacking merchandise, pricing it and then arranging attractive displays throughout the store.

His flair for purchasing and design caused the Galleon to grow in popularity, reaching sales of $1 million a year. One season, he sold more bathing suits than any other retail store in North Carolina. Crocker continued to visualize a "glamorous and glorious" shopping oasis, and he bricked the façade of the building and added dramatic white arches around the windows. A staircase was added to the interior to create two levels of shopping space.

The next step in expanding the Galleon was the creation of a courtyard lined with specialty shops, with names such as Aladdin's Lamp, Court Jester, A Shore Thing, Queens' Ransom, Things Papa Brings, Silver Lining and the Captain's Log. Iron gates invited visitors to enter the courtyard, with its centerpiece protruding ship.

Special events organized by the Galleon included fashion shows, often held at the Sea Fare Restaurant in Nags Head, and the end of season Gambler's Sale, where shoppers' discounts were determined by the spin of a large gambling wheel that was brought in for the occasion. Adding to the festivities, Crocker and staff would dress in casino attire.

Crocker's knack for the unusual didn't stop with the Galleon. In the late 1970s, he opened A Restaurant by George just north of his shopping sanctuary. He added his own whimsy to the restaurant's ambience by decorating it with a jungle theme, which included sheik tents and exotic tablecloths and napkins. Waiters were clad in safari outfits and pith helmets. Entertainment included an after-dinner magic show and jazz on Sunday nights. A 1981 review in *The State* magazine described it as a "fairy-tale place," where "the outside world is almost forgotten."

The Galleon was sold in 1985, and without Crocker's special sparkle in the mix, the shop declined. Both the store and the restaurant were eventually demolished—a very sad ending for a place that had been so lively and magical.

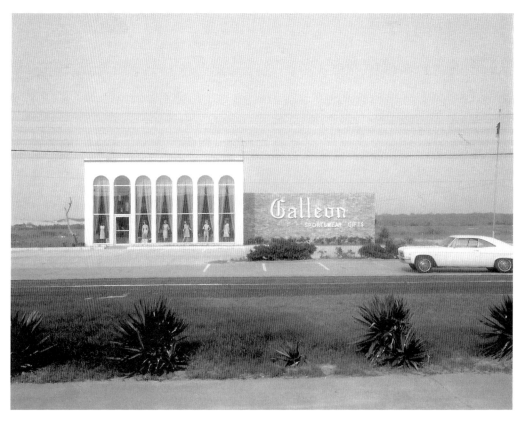

The Galleon Esplanade, with its stately arched windows. *Photo by Aycock Brown, Outer Banks History Center, circa 1970.*

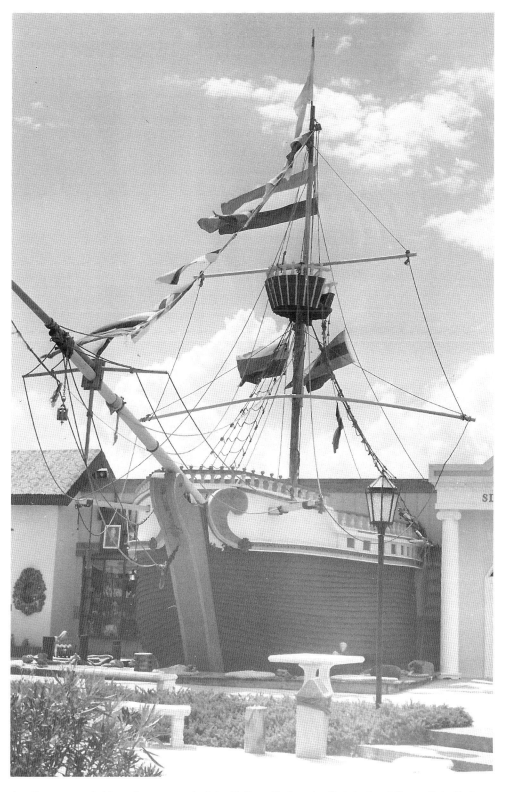

A galleon protruded into the courtyard of the Galleon Esplanade. *Photo by Aycock Brown, Outer Banks History Center, circa 1970.*

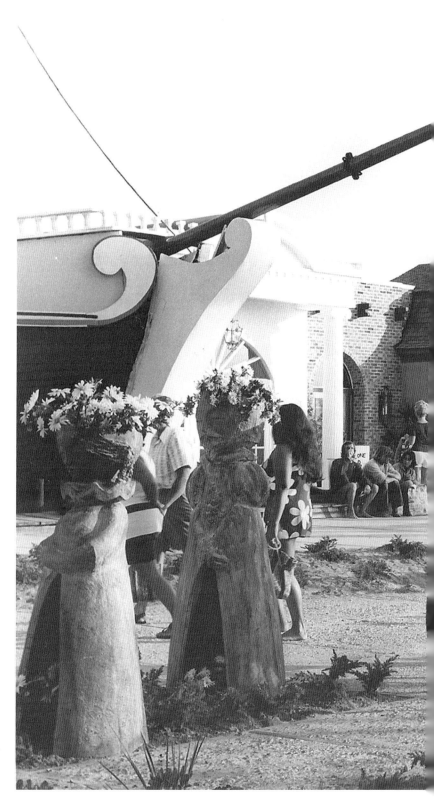

Interior of the courtyard at the Galleon. *Photo by Aycock Brown, Outer Banks History Center, early 1970s.*

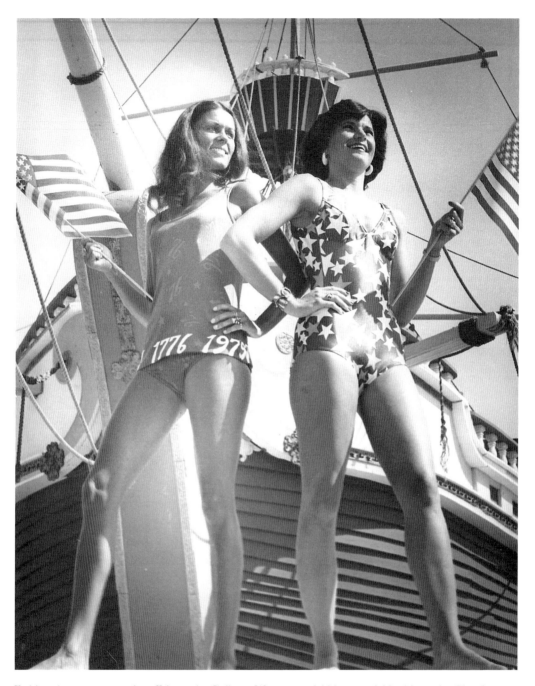

Fashion shows were popular affairs at the Galleon. Women model bicentennial bathing suits. *Photo by Aycock Brown, Outer Banks History Center, circa 1976.*

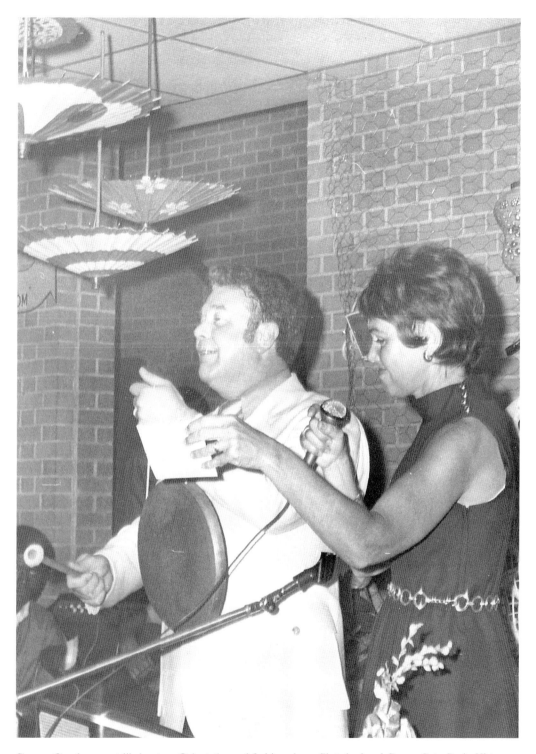

George Crocker, most likely at an Orient-themed fashion show. *Photo by Aycock Brown, Outer Banks History Center, circa 1970.*

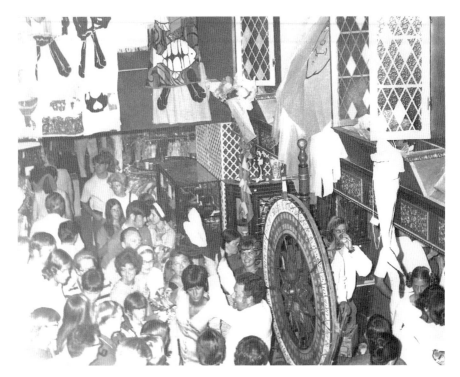

End of the season Gambler's Sale. Galleon owner George Crocker is shown at center with his arms raised. *Photo by Aycock Brown, Outer Banks History Center, early 1970s.*

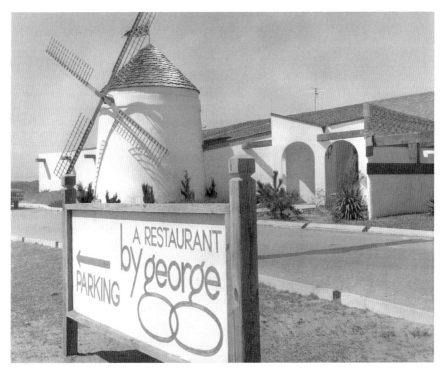

A Restaurant By George. *Photo by Aycock Brown, Outer Banks History Center, circa 1978.*

Restaurants and Taverns

The Discotheque-A-Go-Go

The Discotheque-A-Go-Go was billed as North Carolina's first discotheque, and it featured "sophisticated adult entertainment." The nightclub was located at the north end of the Beach Road and was in operation for a short time. A 1966 advertisement listed dancing, movies, tapes, records, cold drinks and sandwiches for an adult clientele. Those under eighteen were not permitted. A cover charge was levied from 2:00 p.m. to 2:00 a.m. Reliable sources claim that customers were served by topless waitresses.

The establishment later became the Beachcomber Lounge, where gambling purportedly took place until a judge was said to have lost a lot of money one night and put an end to the gaming.

Oasis Restaurant

The Oasis Restaurant on the causeway in Nags Head was especially known for its lace corn bread and the barefoot waitresses who served dinners in their uniform of white Bermuda shorts. The Oasis hired college coeds looking to earn money during their summer break from classes, and it even provided them with onsite housing. Violet Kellam opened the Oasis, also known as the Fisherman's Oasis, around 1950. Kellam has been described as a vivacious and congenial woman, who enjoyed greeting customers and visiting them at their dinner table.

The Oasis changed ownership over the years, and was known as the Dock in the 1980s, but it always remained popular due to its good food and great waterfront location. The community was saddened when the restaurant caught fire and burned in March 2004; a seafood steamer ignited chemical fumes while the floors were being stripped.

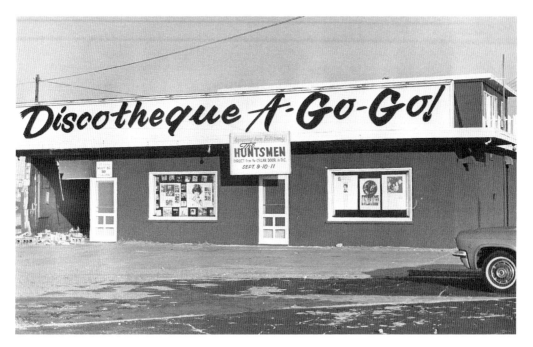

The Discotheque-A-Go-Go later became the Beachcomber Lounge. *Photo by Aycock Brown, Outer Banks History Center, circa 1966.*

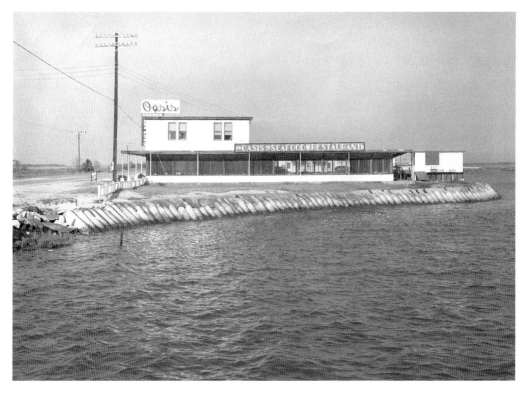

The Oasis's sound-front dining room and delicious food made it an Outer Banks favorite for years. *Photo by Aycock Brown, Outer Banks History Center, circa 1968.*

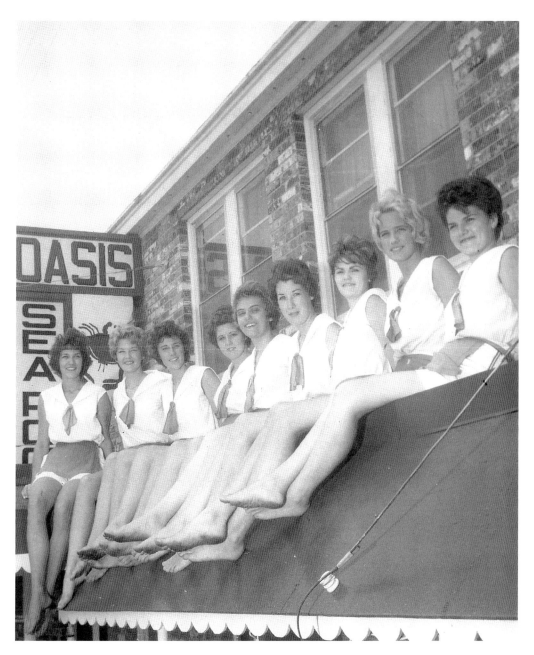

The Oasis's famous barefoot waitresses pose atop the restaurant's awning. *Photo by Aycock Brown, Outer Banks History Center, circa 1968.*

THE DRAFTY TAVERN

The Drafty Tavern was a rustic roadside bar and restaurant on the Manteo side of the Nags Head–Manteo causeway, near the present entrance to Pirate's Cove, a residential boating community. Because it was situated on a canal, boaters could cruise over and dock behind the tavern to enjoy steamed crabs or pizza. The interior featured a long bar, small dance floor, a jukebox and pool tables. Being the closest watering hole to Wanchese, the Drafty Tavern was a popular place for trawler boat workers when they returned to the docks after a long fishing trip.

The rough nature of the Drafty has caused the drinkery to achieve legendary status. Fights were known to break out over issues such as women or rules for shooting pool; patrons recall broken pool sticks and flying beer bottles. Sometimes the fighting even spilled out into the parking lot. George Midgett was said to have initiated many brawls, which his cousin Mac would have to finish.

In 1972, Lance Newman purchased the Drafty Tavern from Lois Saunders and immediately tried to "clean the place up," raising the price of beer from twenty-five to thirty-five cents. He claims to have kept a shotgun behind the counter, but he only had to show it on one occasion. The establishment changed hands a couple of times before it was torn down.

Aerial view of the Drafty Tavern. The building began as the "Toot and Tell It" at the midway intersection on Roanoke Island, but was later moved. *Photo by Aycock Brown, Outer Banks History Center, circa 1973.*

JOCKEY RIDGE RESTAURANT

Pat Bayne's Jockey Ridge Restaurant was located on Beach Road in front of the Nags Head sand dune. Open twenty-four hours a day in season, Jockey Ridge Restaurant specialized in an early breakfast, sandwiches of all kinds, steak, chicken and seafood dinners. An oddity of the eatery was pennies in the ceiling, which were stuffed into cracks in between slats of the knotty pine planks. Jockey Ridge Restaurant was torn down to make way for the construction of the U.S. 158 bypass in 1957.

Bayne later opened a new Jockey Ridge Restaurant south of Gray's Department Store in Nags Head, which included a small dwelling in the back used to house the seasonal waitresses. In 1967, Dick Harper and Lionel Edwards purchased the building and continued in the restaurant business. Harper was particularly impressed by a hardworking waitress, Linda, whom he later married. Together they ran the restaurant for a number of years. That building is still standing today.

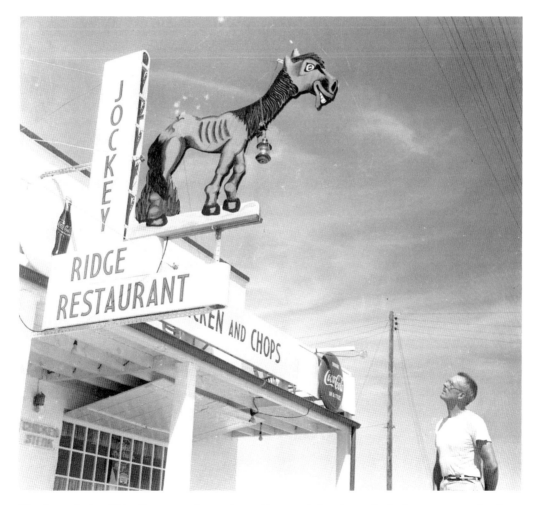

The sign at Jockey Ridge Restaurant featured a real lantern tied to the neck of a horse, representing the legend of Nags Head. *Photo by Aycock Brown, Outer Banks History Center, 1956.*

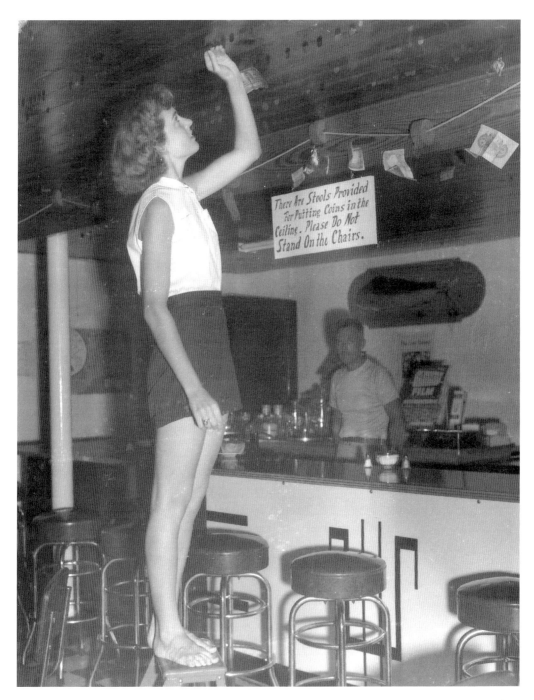

A young lady places her coin in the ceiling at Jockey Ridge Restaurant. *Photo by Aycock Brown, Outer Banks History Center, 1953.*

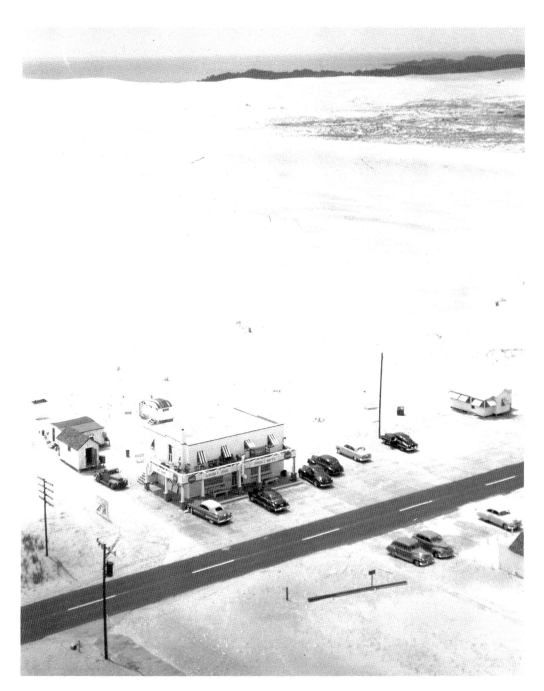

Aerial view of Jockey Ridge Restaurant at the base of Jockey's Ridge. *Photo by Roger P. Meekins, Outer Banks History Center, circa 1950.*

THE REEF DINING ROOM

Opposite the Oasis Restaurant was Dick and Ann Gray's Reef Dining Room, which specialized in seafood–fried shrimp, clams on the half shell, sautéed and fried seafood combo platters–and steaks and chicken, too. While the Oasis boasted of its lace corn bread, so did the Reef. In fact, a 1964 review of the restaurant refers to it as "Ann-originated lace cornbread" and states that the Grays discovered it on a trip to Mexico, where they observed Indian women cooking it over an open fire.

Around 1970 the Reef was purchased by Ira and Shirley Spencer, who owned and operated Spencer's Restaurant in Manns Harbor for a number of years. They named their new Nags Head restaurant Spencer's Seafood Safari, and ran it with the help of their six sons and two daughters.

Mrs. Spencer enjoyed the work, especially interacting with all the people. She could cook, waitress, clear tables, hostess and even pop into the kitchen and expedite when things got busy. The Spencer children helped out as waiters and waitresses, as well as in the kitchen. If they were too young to work in the restaurant, they helped clean fish. Mr. Spencer tended to the restaurant supplies and ordering.

The family used locally caught fish and shrimp, which were cleaned by hand for the restaurant. Ira and Shirley's oldest son, Duke, served as headwaiter for a time. Some years, he would run a charter boat during the day and then work at Spencer's during the evenings. The family also owned a ninety-eight-foot steel-hulled trawler, the *War Cry*, and often served flounder they caught and processed onboard.

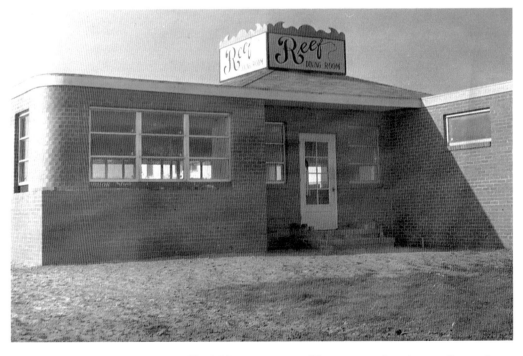

The Reef Dining Room on the Nags Head–Manteo causeway. The restaurant later became Spencer's Seafood Safari and the Ship's Wheel. *Photo by Aycock Brown, Outer Banks History Center, 1955.*

Notable guests at Spencer's Seafood Safari included Andy Griffith, who was a regular patron, and popcorn mogul Orville Redenbacher. The restaurant was sold again in 1985 and became the Ship's Wheel for a handful of years. It was torn down when the Melvin Daniels Bridge, or "the little bridge," was expanded. It is now the site of a public access parking lot for fishermen and crabbers.

EL GAY

The El Gay Restaurant, operated by Eddie and Irene Brown, could be found between Mileposts 15 and 16 on the Beach Road in Nags Head, adjacent to the El Gay Motel. The wood-paneled dining room was expanded in the mid-1960s. The Browns were proud of their delicious food and fast and friendly service. The restaurant specialized in seafood, as well as traditional down-home meals. It was said that the El Gay was one of the first restaurants on the beach to serve grits. After it closed, the El Gay Restaurant remained vacant for many years and fell into an advanced state of decay before it was torn down. The El Gay Motel, which was later called the Gay Manor, survives today as the Manor Motel.

An unknown cyclist in front of the El Gay during a stop on his trip from Philadelphia to Florida. *Photo by Aycock Brown, Outer Banks History Center, 1954.*

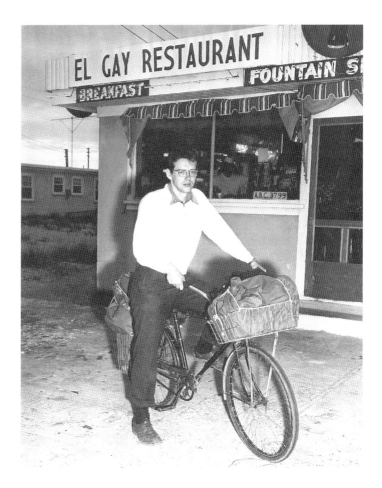

Other Hotels and Businesses

THE WILBUR WRIGHT HOTEL

The Wilbur Wright Hotel was built by Thomas Baum, who operated an early ferry service to the Outer Banks before bridges connected them to the mainland. His daughter, Diane Baum St. Clair, managed it. It has been written that Mr. Baum asked Orville Wright if he might name the inn after him, but Orville asked that the establishment be named after his brother, who died in 1912. As with many Outer Banks hotels and inns, the Wilbur Wright operated seasonally.

The guestbook from the hotel's early years records guests coming from Virginia and North Carolina, as well as from distant cities such as New York, Dallas, Louisville, Buffalo, Chicago, Omaha and Miami. Guests included Mrs. Archibald M. McCrea of Carter's Grove Plantation, Charles Dietz of Dietz Publishing in Richmond and Mr. and Mrs. John D. Rockefeller Jr. from New York City.

During World War II, the inn kept busy; despite gas restrictions, guests came from closer locales, as well as Baltimore and Washington, D.C. Many servicemen visited the Wilbur Wright, coming from Langley Air Force Base in Virginia and the navy blimp base in Weeksville, North Carolina, and a large party of men from the VP-211 Patrol Squadron out of Naval Air Station, Norfolk, enjoyed some time off there in the mid-1940s.

Amenities at the Wilbur Wright included the First Flight Dining Room (which served over one thousand meals a day during its peak), shuffleboard, volley ball, archery, lifeguards, children's activities and a swimming pool.

"It was a cool old building," recalled Randy Friel, who lived at the Wilbur Wright back in the 1970s. "There was a suite of rooms on the floor above me where the bands who played the Casino stayed. A band would come for a week and play from Tuesday though Sunday. A different band every week."

The Wilbur Wright was destroyed by a midsummer waterspout in July 1978.

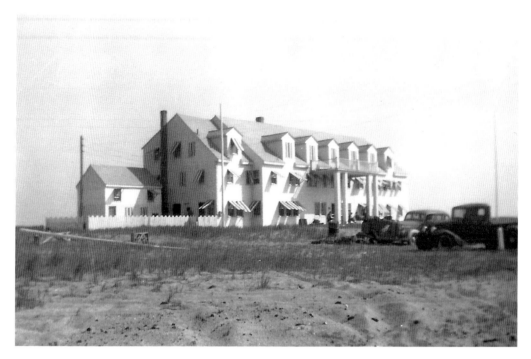

The Wilbur Wright Hotel stood oceanfront in the vicinity of the Wright Brothers National Memorial. *Outer Banks History Center, circa 1940.*

NEWMAN'S SHELL SHOP

Jess and Mary Newman's first shop was on the north end of Roanoke Island, and it sold trinkets to visitors on their way to *The Lost Colony* drama. Mr. Newman was born in Kansas, although his family had ties to Virginia. He came to Roanoke Island as a WPA worker in the 1930s. Mrs. Newman was a local woman, whose father served in the United States Life-Saving Service.

According to Lance Newman, son of Jess and Mary, one day a truck carrying seashells broke down on Roanoke Island, and Mr. Newman purchased a load of them, thus beginning his career in the seashell business. Around 1947, he and Dick Jordan began making concrete blocks from beach gravel and built two buildings on the Beach Road in Nags Head, near Milepost 14. One became Newman's Shell Shop, with living quarters upstairs for the Newman family, while the other was known as the Snap Shop, which sold film and had photographs developed.

In addition to purchasing shells from the Philippines, the Newman family would travel to Florida or Mexico on Christmas breaks to buy shells to bring back to sell in the store. They would also obtain live conches from local trawler boats and clean the shells to prepare them for sale.

In 1957, the Shell Shop and the family's living quarters burned down in a fire started by an ember from the fireplace. Also lost was a collection of shells valued at $10,000 that Mr. Newman had purchased from seashell aficionado R. Tucker Abbot. The cleanup began

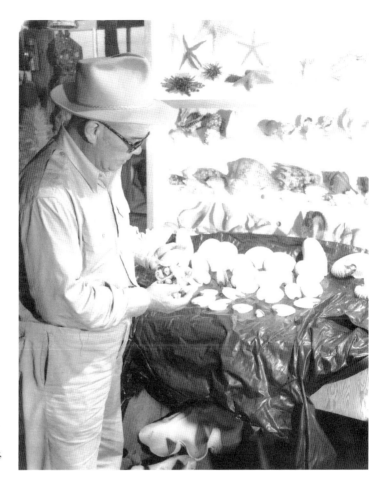

Right: Jess Newman and some of the exotic shells on display at his shell shop. *Photo by Aycock Brown, Outer Banks History Center, 1953.*

Below: Newman's Shell Shop, boarded up near the end of its existence. *Photo by Penne Sandbeck, North Carolina State Historic Preservation Office, 2002.*

two or three days later. Ras Wescott, of the Nags Head Casino, even towed a small camping trailer down to the site of the shop and offered it for the family to live in while the new shop was under construction. A new home for the Newmans was built behind the new store.

Although it encountered flooding in 1962, during the Ash Wednesday Storm, Newman's Shell Shop delighted visitors with its displays of thousands of shells from around the world for over fifty years. The building was torn down in the early 2000s.

CAROLISTA'S

In 1962, Carolista Fletcher Baum began a jewelry studio in a small building in Nags Head. Four years later, she renovated a larger building for her shop and studio, which was delightfully topped off with a twenty-sided second-floor addition. It was advertised as the first jewelry store on the Outer Banks. In 1967, Baum opened an additional jewelry shop in Chapel Hill.

Her Nags Head shop featured handmade jewelry from both precious and semiprecious stones, locally made woodcrafts, hand-knitted sweaters and paintings. In the 1980s, a tobacco shop was located upstairs, where local hipsters could purchase clove cigarettes.

A community activist and preservationist, Carolista was instrumental in saving both Jockey's Ridge and the Chicamacomico Lifesaving Station, the latter of which earned her the North Carolina Historic Preservation Award of Merit in 1977. Additionally, she rescued some of the outbuildings of old Nags Head structures and moved them onto the property behind her shop. Plans were to create a unique group of artists' galleries and studios out of them.

Carolista died young, and after her shop closed, it was rented as a residence. It was during this time that it was referred to as "the Round House," becoming a well-known party house and home to several local hardcore musicians. The Round House burned down around 2003. Most of the outbuildings that had been relocated behind the shop were removed in 2008; however, some of their interior and exterior features were preserved and are now part of the Atlantic Street Bed and Breakfast in Kill Devil Hills.

HOTEL PARKERSON

The cedar-shaked Hotel Parkerson was built on the oceanfront during the 1930s, near Milepost 10. Those who remember it say that Parkerson's was quite fancy for its time. It boasted of fine food and comfortable rooms at reasonable rates. Mr. and Mrs. L.S. Parkerson operated the establishment seasonally from 1936 to 1944, until Mr. Parkerson died tragically in the aftermath of the great hurricane of September 1944.

Mrs. Parkerson, née Elizabeth Quidley, had grown up on the Outer Banks, her father having served in the United States Life-Saving Service. After her husband's death, she continued to run the hotel and enjoyed catering to sportsmen. Breakfast was served beginning at 6:00 a.m., an hour earlier than most other hotels and inns. Cottages and apartments were also available.

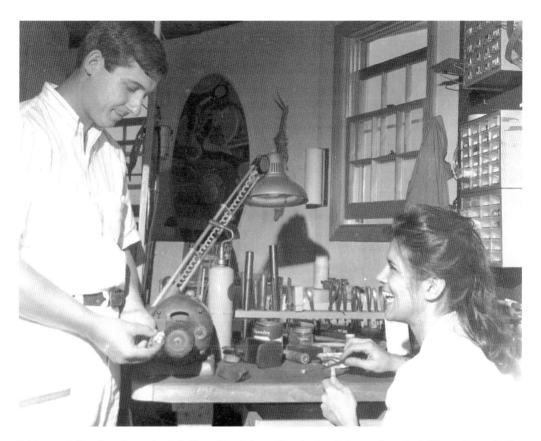

Walter and Carolista Baum in their Nags Head shop. *Photo by Aycock Brown, Outer Bank History Center, 1967.*

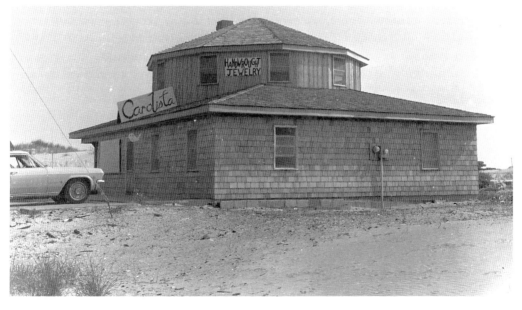

Carolista Jewelers, with its signature twenty-sided second floor, was a recognizable landmark in the historic district of Nags Head for twenty-five years. *Photo by Aycock Brown, Outer Banks History Center, 1967.*

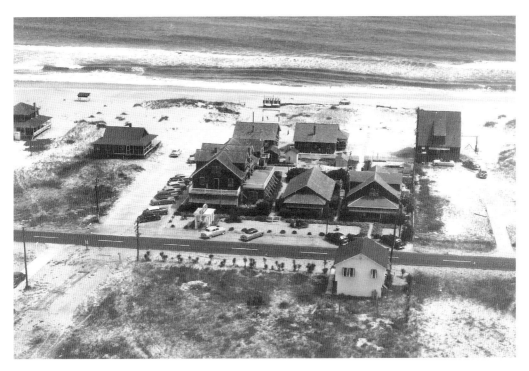

Aerial view of Hotel Parkerson, cottages and outbuildings. *Photo by Roger P. Meekins, Outer Banks History Center, circa 1954.*

Hotel Parkerson shut up tight the summer following the Ash Wednesday Storm. Although not visible in this photo, the hotel suffered damage during the infamous nor'easter. *Photo by Aycock Brown, Outer Banks History Center, 1962.*

As Mrs. Parkerson grew older, her health began to fail, and she sold the establishment in 1960. A glitch in the sales transaction caused the matter to be taken to court, and while tied up in litigation, the Hotel Parkerson was damaged by fire. It also suffered damage during the Ash Wednesday Storm of 1962. The court case was not settled until 1967, two years after Elizabeth Parkerson's death. The building is no longer standing.

NAGS HEAD ICE, FISH AND COLD STORAGE

Brothers Charles and Carl Nunemaker started their ice and cold storage business on the Virginia Dare Trail in Nags Head in 1951. In addition to supplying ice to hotels, restaurants and businesses, they sold fish acquired from local fishermen. A 1953 advertisement listed "fish cleaning and dressing" as a specialty. In 1966, the business was divided. Charles worked out of Colington, buying fish and selling them to fish markets in New York City. Carl and his wife, Sally, continued to run the store. By that time, many businesses had installed their own ice machines, so the Nunemakers added additional merchandise in the store to diversify their offerings.

As the Outer Banks expanded and more and more large food stores opened, business for the Nunemakers declined. They closed up shop in 1988.

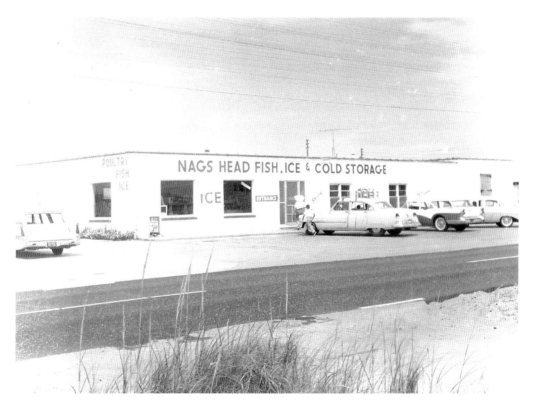

Nags Head Fish, Ice and Cold Storage was a quarter mile north of the Carolinian Hotel on the west side of the Beach Road. *Photo by Aycock Brown, Outer Banks History Center, 1958.*

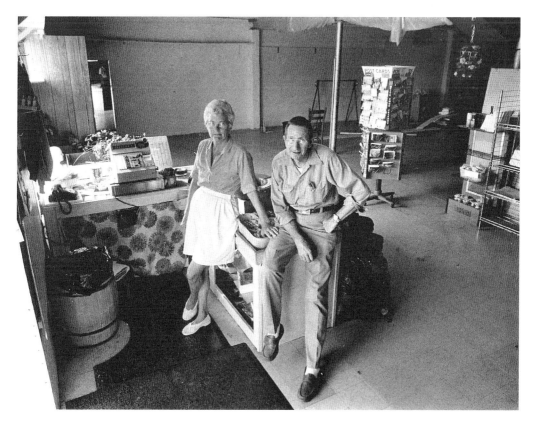

Sally and Carl Nunemaker in their Nags Head store around the time of closing. *Photo by Drew C. Wilson, Outer Banks History Center, 1988.*

KESSINGER'S

This two-story white building on the west side of the Beach Road in Nags Head housed the Nags Head Post Office and a hardware and variety store that carried a little bit of everything. The upstairs had rooms that were available for rent, which shared a common bathroom at one end of the hall. In 1962, they rented for five dollars a night. Mr. and Mrs. Kessinger lived in a small suite in the rear of the store.

In later years, Mr. Kessinger sold the building to some out-of-towners, who established a gambling parlor on the top floor, where card games were played. This became known as the Beach Club. A steakhouse operated downstairs, where steaks were kept in a meat case in the front of the restaurant for patrons to come in and choose their own steak. The building is no longer standing.

KITTY HAWK LODGE

The Kitty Hawk Motor Lodge was built in the late 1940s on the Kill Devil Hills oceanfront, possessing thirty rooms with both private and connecting bathrooms. Owners Goldie

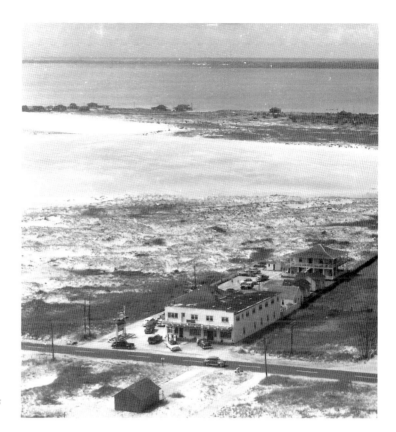

Kessinger's variety store and post office. *Photo by Roger P. Meekins, Outer Banks History Center, circa 1950.*

and Edmund Melson believed that meals were an important part of a family vacation, and they prided themselves on the dishes served in the dining room. Chicken stew with dumplings was one of their specialties. Like many older cottages and motels, the Kitty Hawk Motor Lodge ended up as housing for college students, who flocked to the beaches every year for summer jobs.

THE SEA OATEL

Archie and Lina Burrus's Sea Oatel was located on the oceanfront at the southern end of Nags Head's business district. It underwent many additions over the years. In 1953, 16 units were added. In 1958, the Sea Oatel featured 28 luxuriously furnished rooms; by 1964, the room count was 84. In 1968, 18 more rooms brought the total to 102. An elevator (one of the first on the Outer Banks) was also added in 1968. The hotel was in operation for roughly forty years.

In the Sea Oatel's later days, the building was identifiable by its pink bricks and a gorgeous bed of mixed jonquils that bloomed in front each year. When the hotel was razed about 2005, a remarkable thing happened. During the demolition, the jonquil bulbs that bloomed each spring were dispersed and continued to bloom long after the Sea Oatel was gone—a wonderful reminder of times past.

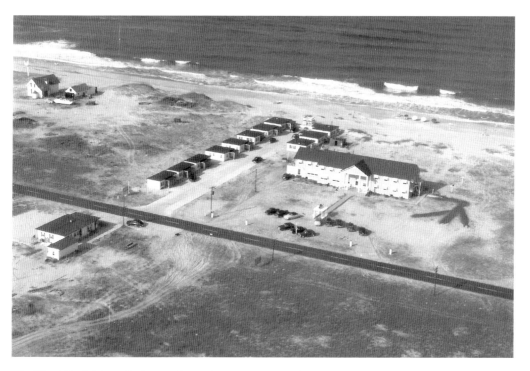

The Kitty Hawk Motor Lodge was located near present-day Clark Street in Kill Devil Hills. *Photo by Roger P. Meekins, Outer Banks History Center, circa 1950.*

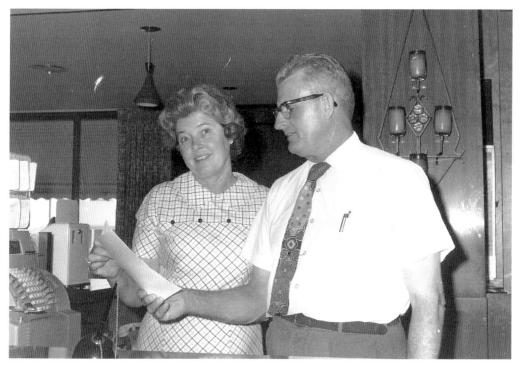

Lina and Archie Burrus pose for a photo for the Quality Court Hall of Fame. *Photo by Aycock Brown, Outer Banks History Center, 1971.*

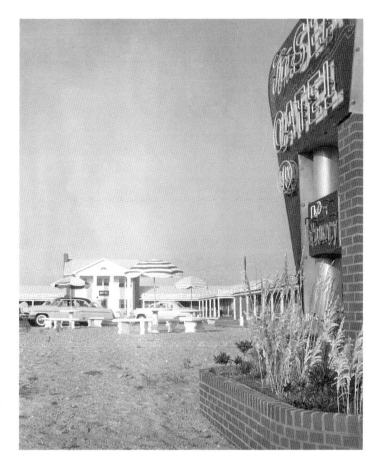

Right: An early view of the Sea Oatel. Over the years, more and more rooms were added. *Photo by Aycock Brown, Outer Banks History Center, circa 1955.*

Below: The Sea Oatel during its later days, when it was known as the Pink Palace because of the colorful bricks used in construction. *Photo by Aycock Brown, Outer Banks History Center, circa 1964.*

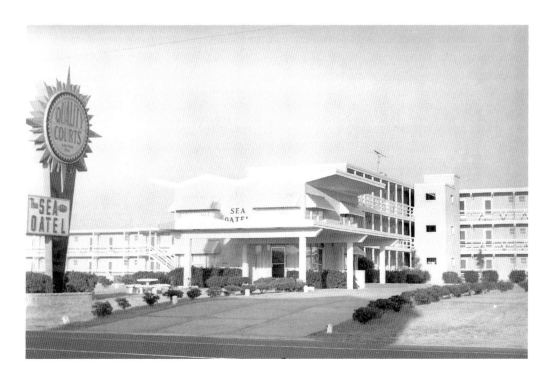

Recreation

DOWDY'S AMUSEMENT PARK

Dowdy's Amusement Park in Nags Head had the humble beginning of just a place to ride go-carts. Joe Dowdy purchased the five-acre tract in 1962 and had it cleared so his son might have a place to ride his go-cart. The idea caught on with other children, who were soon asking if they could rent carts and ride there as well.

In 1964, Dowdy built a cinderblock building and added ten bowling alleys to the fledgling entertainment spot, but he removed them soon afterward in favor of arcade games and pinball machines. Carnival rides, including a Ferris wheel, followed. When Funland Park, on the Beach Road next to Nags Head Bingo, closed down in 1965, Dowdy quickly bought its old rides and moved them to his growing amusement park.

While go-carts were still an attraction, kiddie rides, bumper cars, Tilt-a-Whirl, Spider, Whip and even two roller coasters could be found at Dowdy's over the years. A drive past Dowdy's on a summer night with your car windows down—taking in all the bright, colorful lights, smelling the warm evening air mixed with the aroma of popcorn and cotton candy and hearing the sound of rides and the screams of their riders—gave one a contented feeling, as if summer would last forever.

Thousands of fun-loving family vacationers' annual pilgrimage to the beach was not complete without an evening at Dowdy's. The amusement park closed at the end of the 2005 summer season.

JOCKEY'S RIDGE MINI-GOLF

Jockey's Ridge Mini-Golf was built in the mid-1970s, bordering Jockey's Ridge State Park's southeast boundary. Before opening each year, the site had to be dug out because of the sand from the dunes that had blown over during the winter.

The 3.1-acre parcel was sold to the state in 1987, and it was added to Jockey's Ridge State Park. Superintendent George Barnes and Alan Alligood of the North Carolina Division of State Parks helped remove what fixtures they could from the mini-golf, which included a large octopus, a dragon with a hornet's nest in its mouth, a ship and an

Youngsters on the Tilt-a-Whirl, one of Dowdy's attractions. *Photo by Drew C. Wilson, Outer Banks History Center, 1992.*

Joe Dowdy enjoys an ice cream cone at his amusement park. *Photo by Drew C. Wilson, Outer Banks History Center, 1992.*

anchor. The latter two were donated to the Ark Church in Nags Head. What wasn't given away was hauled off to the dump, except for a concrete sand castle that was left intact, as there was neither money nor means to remove it. Barnes realized that leaving the castle was a benefit to the park because it was a helpful example for park staff to explain sand migration to visitors.

The castle was eventually covered, leaving only ten inches of its towers visible, and then over time it was again exposed. One day, during his rounds of the park, Barnes noticed someone had removed one of the castle towers in an effort to steal it as a souvenir. It was later found amidst the dunes, where the culprit had abandoned it, presumably because of its weight. It was subsequently covered with sand. The castle can still be seen protruding from the Jockey's Ridge dunes.

HOLIDAY MARINA

The Holiday Marina was located sound-side at the west end of Sportsman Drive in Kill Devil Hills. Bill Wilkerson and Charlie Butler built the original structure, which washed away during Hurricane Donna in 1960, but was later reconstructed.

Sailboat and motorboat rentals were available, as well as a tackle shop, gas pumps on the pier, docking facilities, a launch ramp, sailing lessons and pier fishing for kids.

After changing hands several times, Dave Menneker purchased the establishment in the mid-1970s, and for ten years it was the Sound Side Folk and Ale House, where jazz, blues and country musicians played for local audiences. North Carolina bluegrass great

Jockey's Ridge Mini-Golf soon after opening. *Photo by Aycock Brown, Outer Banks History Center, circa 1976.*

Jockey's Ridge Mini-Golf shortly before removal. *Photo courtesy Jockey's Ridge State Park, circa 1988.*

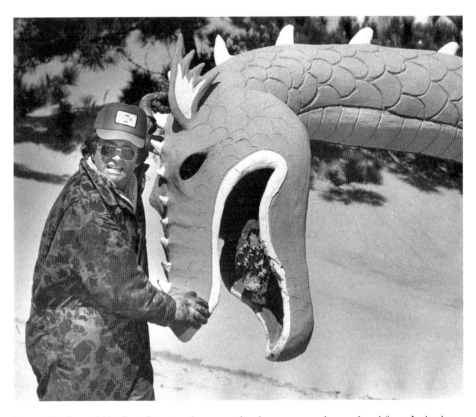

Henry Norfleet of Norfleet Construction precariously removes a dragon head from Jockey's Ridge Mini-Golf. *Photo by Drew C. Wilson, Outer Banks History Center, 1988.*

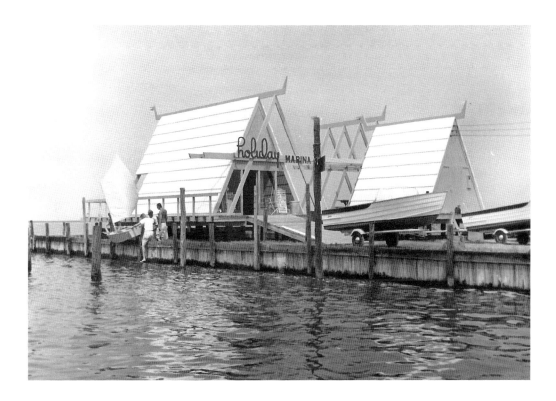

Above: The A-framed Holiday Marina on the shore of Kitty Hawk Bay. A variety of boats were moored off its Sound Side pier. *Photo by Aycock Brown, Outer Banks History Center, date unknown.*

Right: A young lady in a sailfish sailboat, which were available for rent at the Holiday Marina. *Photo by Aycock Brown Outer Banks History Center, date unknown.*

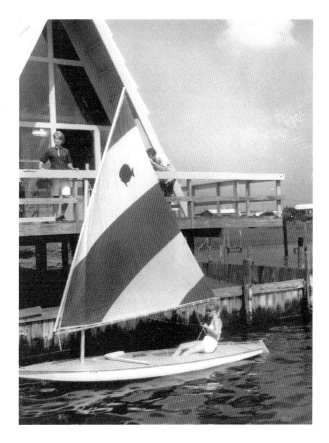

Doc Watson even played at the Sound Side. Andy Griffith attended both performances and asked to meet Watson between shows.

The Sound Side was an inconspicuous watering hole, where patrons could listen to acoustic music, especially on locals' night. Food and drinks were enjoyed in the dark, rustic interior or on the deck. It was a prime spot for people to gather, especially at sunset.

BINGO

A 1950 edition of *Surfside News* listed no fewer than four bingo establishments in Nags Head alone. Al's Bingo at the Recreation Center billed itself as "the Bingo of Smithfield Hams," where "name brand merchandise" was given away as prizes. Leary's Bingo, across the Beach Road from Al's, claimed to be "the original beach bingo" and was also known as Jones and Leary Bingo and Nags Head Bingo. By 1951, the Casino Bingo offered games and prizes just south of its nightclub namesake. The Nags Head Beach Club also offered bingo for a time.

While working on this book, two stories have been told to the author by two separate upstanding individuals who worked at the bingo parlors in their youth. Both stories involve deceptive methods to ensure that pretty girls might win games. One method involved enticing the young ladies to sit close to the number caller, who was seated higher than the bingo players. The number caller could simply look down and see which number the pretty girl needed in order that she might win. When the next number was called, it was the one the girl needed, whether or not that was the actual number that was drawn.

The second method involved walking by a pretty girl and, as a number was called, simply picking up her card (scattering the pieces of corn that were used as card markers), holding it up and proclaiming, "We have a winner!" and then calling out numbers that had already been called, whether or not they were on the bingo card. These were not devious or large-scale plots to cheat people, but were merely a way for a young man to win the attention of an attractive girl.

THE SURF SLIDE

The Surf Slide was the first water slide on the Outer Banks, built about 1978. In order to create the hill on which the Surf Slide would be erected, a man-made lake was formed, where sand was displaced. It is now the pond in the Nags Head Pond subdivision. In the 1980s, locals teased that the job of "pace keeper" at the Surf Slide was one of the best summer jobs around. All you had to do was tell sliders, "Go," all the while working on your tan. The landmark recreational attraction was torn down about 2005.

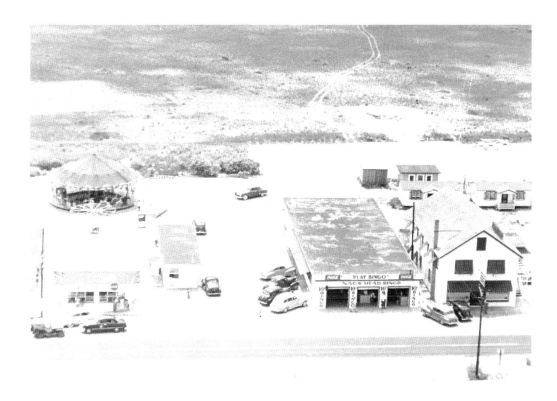

Above: Nags Head Bingo was located across from Mann's Recreation Center. *Photo by Roger P. Meekins, Outer Banks History Center, 1950.*

Right: Bingo was a popular pastime in Nags Head during the 1950s, when at least four bingo parlors were in operation. *Photo by Roger P. Meekins, Outer Banks History Center, circa 1954.*

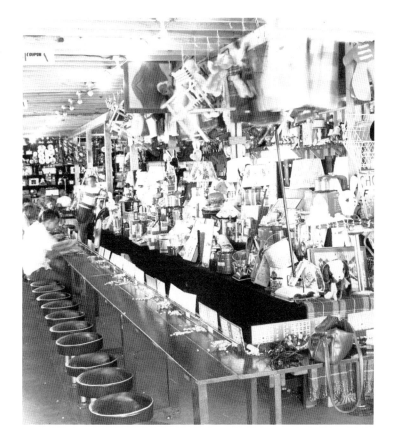

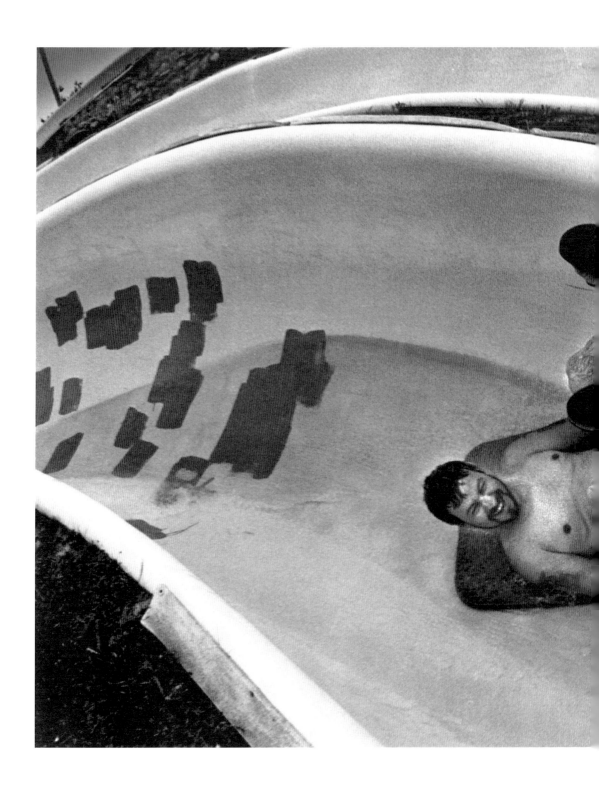

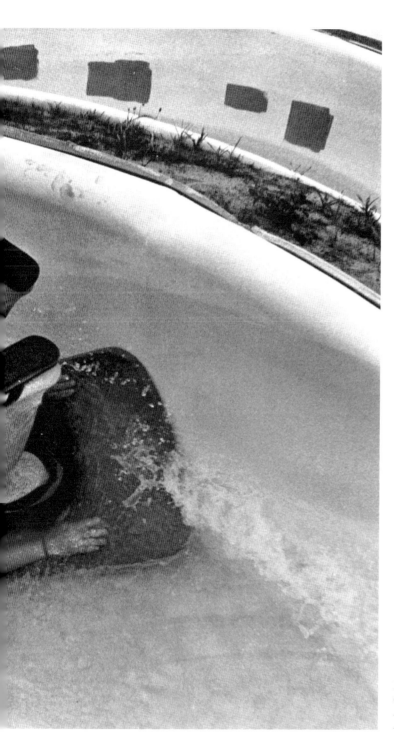

Rick Evans of Roanoke, Virginia, enjoys himself at the Surf Slide. *Photo by Drew C. Wilson, Outer Banks History Center, 1991.*

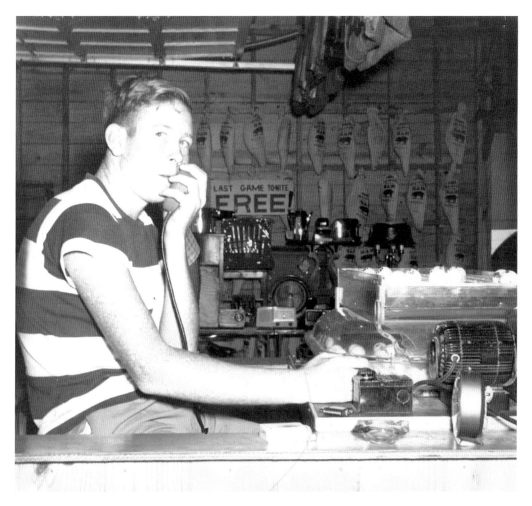

Charles Briggs worked as a number caller at one of the Nags Head bingo parlors. *Photo by Roger P. Meekins, Outer Banks History Center, circa 1954.*

Jennette's Pier

Built in 1939, Jennette's Pier was the first fishing pier constructed on the Outer Banks. It was rebuilt in 1947 (probably after the Hurricane of 1944) and again in 1962, after the Ash Wednesday Storm. Jennette's Pier suffered a fatal blow in September 2003 with the passing of Hurricane Isabel, which took out most of the pier, leaving only a few pilings and the pier house.

In addition to the pier, Jennette's offered accommodations in a motor court and in cottages, with or without kitchens. In 1957, kitchen-equipped cottages rented for fifty dollars a week, and regular rooms for forty dollars. In 1962, nine new two- and three-bedroom cottages with air conditioning, screened porches and wood paneling and floors were added.

The pier house was torn down in 2008. The site is owned by the North Carolina Aquarium Society. Plans are to build a wooden and concrete pier, one thousand feet long and twenty-five feet wide, that will include benches and covered pavilions, wind turbines and teaching areas.

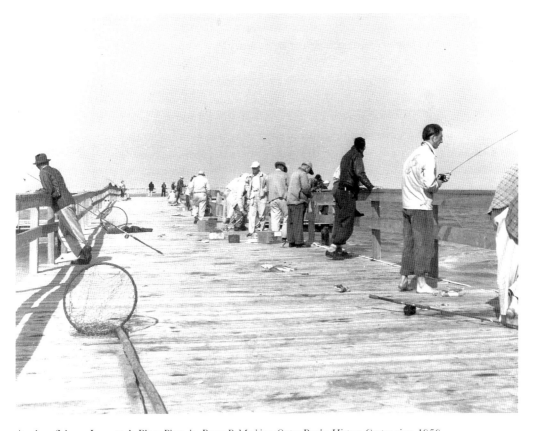

Anglers fish on Jennette's Pier. *Photo by Roger P. Meekins, Outer Banks History Center, circa 1950.*

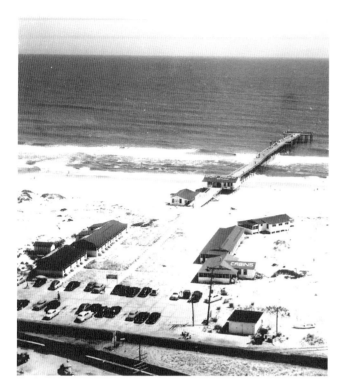

Aerial view of Jennette's Pier and surrounding accommodations. *Photo by Roger P. Meekins, Outer Banks History Center, circa 1954.*

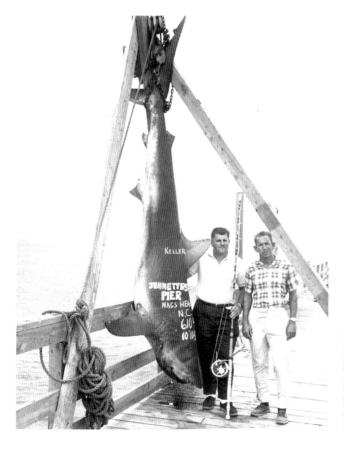

Robert T. Keller of Cleveland, Ohio, landed this 610-pound dusky shark on Jennette's Pier in 1963. Two years earlier, he caught a hammerhead shark that topped 700 pounds. Both are North Carolina state records. *Photo by Aycock Brown, Outer Banks History Center, 1963.*

Assorted Others

Holy Redeemer Catholic Church

Holy Redeemer Catholic Church was built in 1938 on the west side of the Beach Road, just south of the Croatan Inn in what is today the town of Kill Devil Hills. The cost of building and furnishing the church was $5,000. The chapel seated one hundred worshipers and was built primarily of juniper and covered with asbestos shingles. In addition to the church, a small priest's quarters were also constructed.

Plans for the chapel were drawn by Professor Stanislaw J. Makielski, an architecture instructor at the University of Virginia. Frank Stick was the contractor of the building project. The idea for a Catholic church on the Outer Banks originated with Mrs. Harry Lawrence, a practicing Catholic who donated the land on which the chapel was built. The building was expanded and added to several times during the 1970s and 1980s, but it suffered a fire and was destroyed in 1998. A modern Catholic church was built in Kitty Hawk and was dedicated in 2001.

Log Buildings at Fort Raleigh

During the early 1930s, a series of log buildings were built at old Fort Raleigh on the north end of Roanoke Island, which was thought to be the site of the original settlement of the Raleigh colonists in the late 1500s. Frank Stick designed the structures, which were built by men and boys of the Works Projects Administration, under the direction of Albert Q. "Skipper" Bell. By 1935, the buildings had helped to increase visitation to the site tenfold. However, soon after they were built, experts determined that log buildings did not appear on the American landscape until 1638, and scholars dubbed them "historically inaccurate."

The most endearing of the log buildings was the chapel, built from hand-hewn juniper and topped with a thatch roof. It was an especially popular location for weddings. After the National Park Service took over the Fort Raleigh site in 1941, the log buildings no longer received any upkeep, and by 1946, several had fallen into such a state of disrepair that they were removed. Five additional buildings were destroyed five years later. The

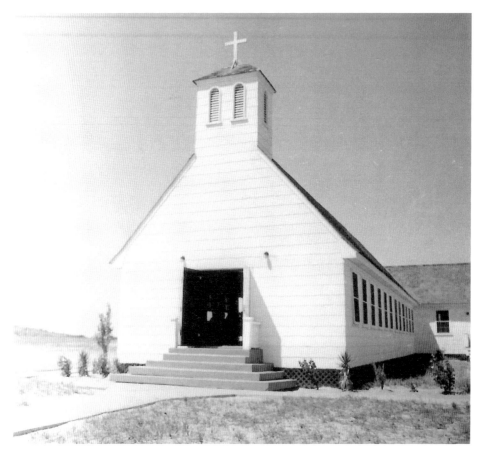

East view of Holy Redeemer Catholic Church. *Outer Banks History Center, circa 1950.*

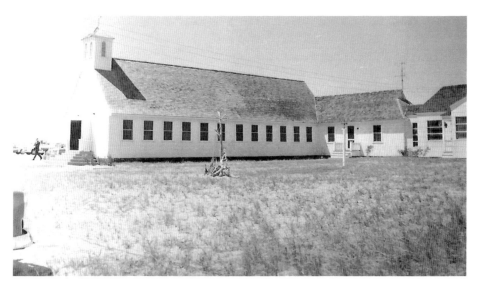

View of church, with priest's quarters to the north, behind the sanctuary. *Outer Banks History Center, circa 1950.*

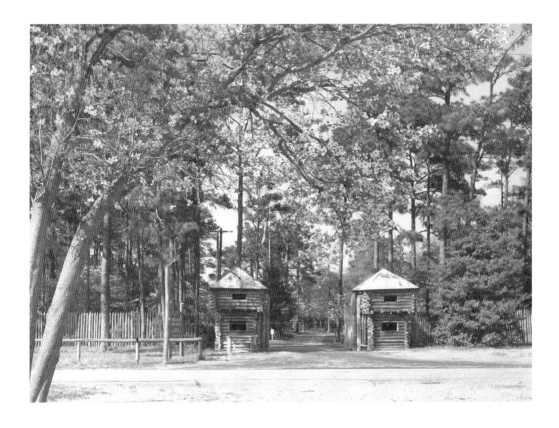

Above: Blooming dogwood trees frame the log guardhouses that marked the old entrance to the Fort Raleigh site. *Photo by Aycock Brown, Outer Banks History Center, date unknown.*

Right: Interior of the log chapel at Fort Raleigh. *National Park Service photo, Outer Banks History Center, date unknown.*

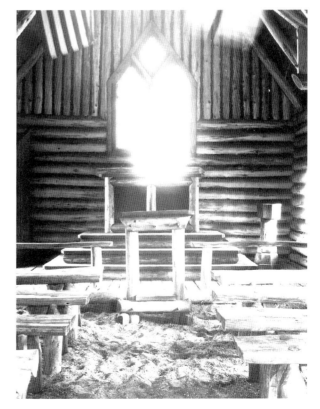

Left: The chapel at Fort Raleigh was the scene of many weddings before it was removed from the park in 1952. *Photo by Aycock Brown, Outer Banks History Center, 1949.*

Below: The John White Cottage was moved from Fort Raleigh in 1965 as part of the National Park Service's Mission '66 program. *Photo by Aycock Brown, Outer Banks History Center, date unknown.*

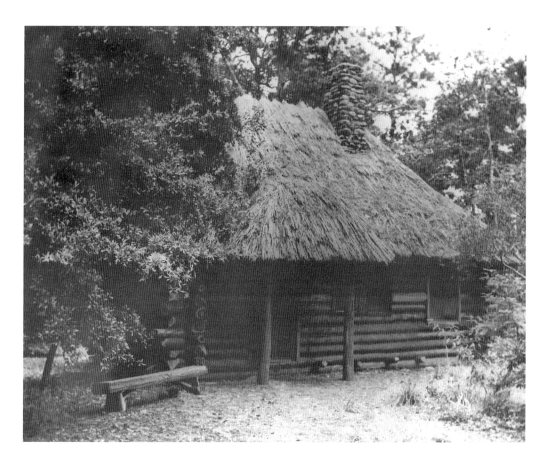

chapel was closed in 1950 and was razed in 1952. The remaining buildings were removed from the park in the 1960s.

THE SIR WALTER RALEIGH STATUE

The Sir Walter Raleigh Statue was a fixture in downtown Manteo from 1976 to 1990. Artist Robert K. Harniman created the twenty-four-foot, fifteen-thousand-pound statue from a five-hundred-year-old cypress tree found in the Tar River Swamp in Pitt County, North Carolina. The statue was carved at the North Hills Fashion Mall in Raleigh, and then became part of the North Carolina Bicentennial Exhibit, which traveled from town to town. It was described as the world's largest free-standing, moveable sculpture.

After the bicentennial, the statue was without a home, and at the suggestion of Jule Burrus, the Manteo Woman's Club raised money to bring Sir Walter Raleigh to Manteo. Although the statue was a bit quirky, some folks liked it; others were quick to point out its anatomical disproportion and resemblance to Paul Bunyan. After a time, the sculpture began to rot, and enterprising woodpeckers exacerbated the situation by pecking away at its wood in search of food.

As a matter of public safety, Manteo officials decided to remove the Sir Walter Raleigh statue from its resting spot at the end of Queen Elizabeth Street. Just as the statue had been created with chainsaws, it was also chainsaws that brought the statue down.

Several people expressed an interest in keeping a portion of the statue as a souvenir. Lynda Midgett, who had been instrumental in raising funds to bring the statue to Manteo, was awarded the statue's head. However, on its way to her home, the statue head rolled out of the back of the pickup truck in which it was riding, breaking into many pieces.

OUTER BANKS GALLERY AND STUDIO

The Outer Banks Gallery and Studio offered summer art classes and lured students with thoughts of painting clouds, the sea, dunes, fishing villages and live oaks. Instruction was given in watercolor, as well as oils, and classes were taught in two separate three-week sessions, one in late June and early July and the other in August. The season culminated in a student art show. Amateurs were given guidance in how to make their work stand out in art exhibits. Students went on to show their works at galleries in Richmond, Norfolk and Raleigh.

Classes were taught by Dorothy Bowie, who had studied, taught and exhibited art in Chicago, Louisville and New York. During the off-season, Bowie painted from her private studio in Petersburg, Virginia. Student housing was offered in a cottage adjacent to the Outer Banks Gallery and Studio, which was located in between the bypass and the Beach Road on what was then Colington Road, but is Ocean Bay Boulevard today. It was in operation from the early 1950s to the early 1980s.

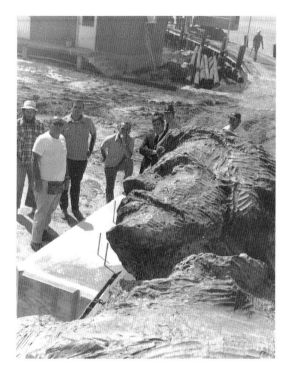

The arrival of the Sir Walter Raleigh statue. It was brought to Manteo on a flatbed truck. *Photo by Aycock Brown, Outer Banks History Center, 1976.*

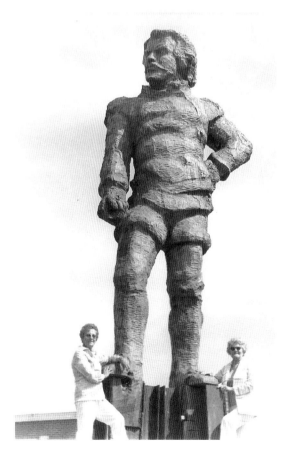

The Sir Walter Raleigh statue was one of the most photographed sights in downtown Manteo. *Photo by Aycock Brown, Outer Banks History Center, circa 1978.*

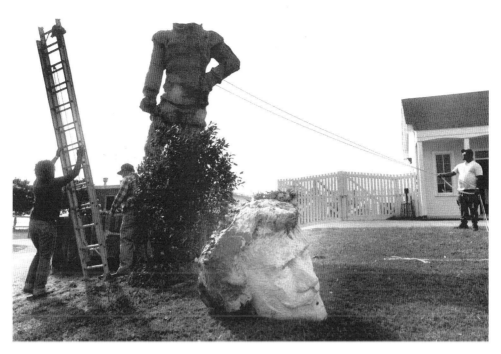

When the Sir Walter Raleigh statue was removed, locals got a chuckle out of the fact that the real Sir Walter Raleigh was beheaded by King James I in 1618. *Photo by Drew C. Wilson, Outer Banks History Center, 1991.*

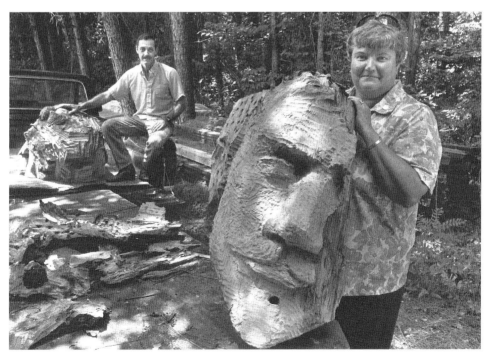

Lynda Midgett with the fractured Sir Walter Raleigh Statue head. Nick Sapone (in the background) carved two small waterfowl sculptures from the remains of the head for Midgett. *Photo by Drew C. Wilson, Outer Banks History Center, 1991.*

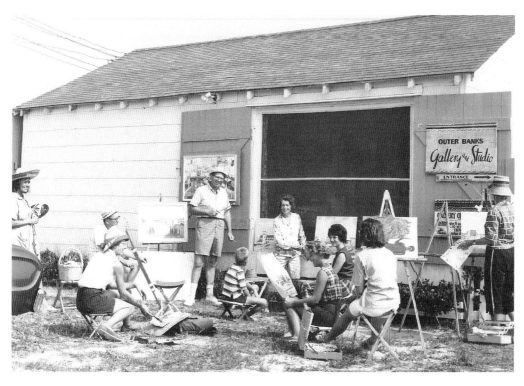

Outer Banks Gallery and Studio art students practice their techniques. *Photo by Aycock Brown, Outer Banks History Center, 1964.*

THE NAGS HEAD WATER TOWER

The Nags Head Water Tower was built in 1963 at a cost of nearly $52,000. The 162-foot, 300,000-gallon tower served the town for forty-four years and was part of the first formal municipal water system. A new 500,000-gallon tower on Eighth Street in Nags Head was completed in 2006, and the old tower, which was no longer needed, was disassembled and removed February 11, 2008.

The photograph shown was taken at Milepost 14.5 on the Beach Road, just as construction of Nags Head's hexagonal town hall and municipal buildings was getting under way. The current municipal building was dedicated on May 18, 1997, and the hexagonal buildings were moved that same year.

ROANOKE INDIAN VILLAGE

Roanoke Indian Village was an interactive outdoor museum representative of a sixteenth-century Algonquian settlement. It was billed as a must-see for American history teachers and students. In season, the site on the north end of Roanoke Island was open daily, with special Indian dancing and chanting on Wednesday and Sunday evenings.

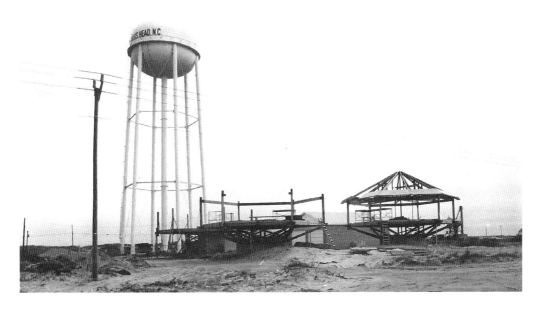

The Nags Head water tower was a directional landmark for over forty years. *Photograph by Aycock Brown, Outer Banks History Center, circa 1973.*

A portion of the old Nags Head municipal building the day it was removed from its original location. *Photo courtesy Jockey's Ridge State Park, 1997.*

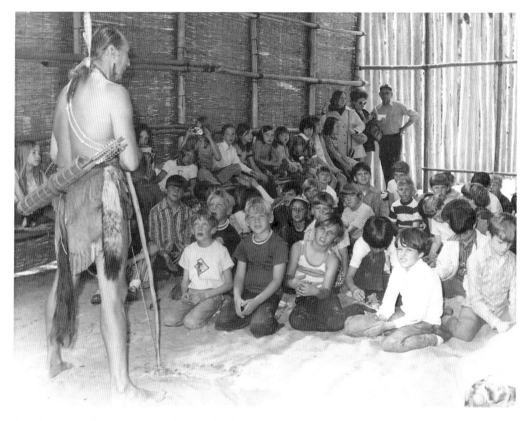

A student group learns about the Algonquian Indians at Roanoke Indian Village. *Photo by Aycock Brown, Outer Banks History Center, circa 1973.*